REMEMBERING

GERMAN VILLAGE

R E M E M B E R I N G

GERMAN VILLAGE

COLUMBUS, OHIO'S HISTORIC TREASURE

JODY H. GRAICHEN

THE
History
PRESS

Published by The History Press
Charleston, SC 29403
www.historypress.net

Copyright © 2010 by Jody H. Graichen
All rights reserved

First published 2010

Manufactured in the United States

ISBN 978.1.59629.287.1

Library of Congress Cataloging-in-Publication Data

Graichen, Jody
Remembering German Village : Columbus, Ohio's historic treasure / Jody Graichen.
p. cm.
ISBN 978-1-59629-287-1
1. German Village (Columbus, Ohio)--History. 2. Columbus (Ohio)--History. 3. German
Americans--Ohio--Columbus--History. 4. German Village (Columbus, Ohio)--Buildings,
structures, etc. 5. Columbus (Ohio)--Buildings, structures, etc. 6. Historic preservation--
Ohio--Columbus.
F499.C76G474 2010
977.1'57--dc22
2010018429

This book is dedicated to the memory of my friend Brent Warner.

CONTENTS

FOREWORD

I grew up in Cleveland, went to college in Columbus, lived for some time in urban neighborhoods in Barcelona and then Reading, England, and came back to Columbus to take a position as an assistant professor in the Division of Comparative Literature at Ohio State University in the late 1960s. My first house purchase was in a suburban neighborhood near campus. At the time, I had no intention of moving to a village community. But that is exactly what I did upon changing jobs in 1978. I moved to German Village and have lived here ever since. Why the change? It would take me too long to tell you. However, Jody Graichen does a far better job with her insightful columns.

Many people have visited historic neighborhoods located in Georgetown, Washington, D.C., Charleston, South Carolina, and other cities whose charm and history have been discussed in a variety of publications. They are tourist destinations and are valued for their appeal, historic restorations and community values. Much of the same could be said for German Village in Columbus, Ohio. This compilation of Jody's columns should open the door for the reader who has never been here to experience what we inhabitants call a wonderful small community located in a big town. We love the charm, its sense of camaraderie and a deeply rooted historic preservation ethic.

Jody's education in public history and in history and journalism lend a sensibility and insight to her columns. These qualities are not often found in articles that address historic preservation or civic associations. She writes for the public, giving people interpretations of the history of German Village

through her use of photographs of the early settlers and their homes in the early 1900s. She writes about the present German Village Commission and its no-frills attitude about preservation. Having herself worked in the office of the German Village Society, she understood the "local politics," as well as the larger political issues surrounding the Society and Commission. She could explain the concerns of residents to the various Columbus city offices that review transportation issues and streetscape design. Over the years, her columns gave public value to historic preservation, expressed the joy of public parks and underlined the importance of volunteerism. Her columns spoke to all of us who live here.

Jody understands and reminds the residents of German Village that they are the caretakers of the structures they live in. German Village simply would not be German Village without its people. However, those people would probably not be here were it not for the buildings, the streetscapes, the parks and, above all, the camaraderie. Villagers have the best of both worlds. We live downtown but in a community that we call a small town. Jody's columns are reminders of that.

<div align="right">

Wayne P. Lawson, PhD
Director Emeritus, Ohio Arts Council
Professor, Public Policy and Art Administration, Ohio State University

</div>

ACKNOWLEDGEMENTS

In writing four years' worth of columns for *ThisWeek* Community Newspapers, I leaned very heavily on individuals, personal histories and accounts, printed sources and others' research. In the office, Katharine Moore, P. Susan Sharrock and Bob Jackson patiently offered column suggestions and sage advice each week, while the German Village Society Board of Trustees, particularly its Historic Preservation Committee, offered countless and invaluable topics for research. I also took advantage of the Meeting Haus Visitor Center volunteers, a group of individuals with more years than me, better true stories than I could dream up and a generosity of both time and spirit that rivals any other. *ThisWeek* reporter David Cross worked collaboratively and professionally with me and never once told his editor how intimidated I was by this weekly endeavor. Historian and fellow *ThisWeek* contributor Ed Lentz is a writer and researcher I admire, and I have been honored to share a page with him. Of course, I am incredibly thankful that Dr. Wayne Lawson agreed, with pleasure I might add, to write the foreword for this book, as his name adds a high degree of academia to my very simple work.

Meeting Haus resources that I utilized on an almost daily basis made their appearances in my columns as well. Sanborn Fire Insurance maps and Columbus city directories were referenced all too frequently. The German Village Society's Fischer Archives, a collection of documents and photographs created by Ralph and Dorothy Fischer, are the backbone of

all I have done in my role as director of historic preservation programs, and the phrase "referring to the files" is too light a description for my usage. This collection embodies all of the German Village Society's historical and archival records and was an enormous gift to discover on my first day of work.

Earlier local history publications such as Connie Walley and Susan Cox's *Six Generations: The Story of German Village,* Jeff Darbee and Nancy Recchie's *German Columbus,* James Tootle's *Baseball in Columbus,* Richard Campen's *German Village Portrait* and Judith Kitchen's *Old Building Owner's Manual* were all frequently perused, and many important projects were interrupted because I couldn't put any one of those books down after finding something new to distract me.

Other works within the Society's library, such as *A History of German Village to Approximately 1900*; *Lager and Liberty: German Brewers of Nineteenth Century Columbus*; the *Spectator*; "Remembering St. Mary's and Monsignor Burkley," an academic report written by Kimberly Moss researching the history of street names; "Deeds of Light," written by German Village resident Craig Walley and printed in the Ohio Historical Society's *Timeline*; church anniversary programs for Trinity Lutheran Church and St. Mary Catholic Church; family histories such as that written by Richard Eilbert, whom I never met but who so thoughtfully mailed me a copy because he wondered if I might be interested in it; the 1935 *Annual Report of the Division of Parks and Forestry*; and the websites www.ohiohistorycentral.org, http://oak.cats.ohiou.edu~cookt/images/history and www.ohiohistory.org, were critical to submitting weekly columns by press deadline.

Personal interviews with Aggie Dorn Carpenter, Dorothy Fischer, Pat Gramelt, Court Hall, Madeline Hicks, Dorothy Hughes, Philip Kientz, William Lenkey, Jeannine Morbitzer, Pat Phillips, Michael Rosen, Cloene Samuels, Geoff Schmidt, James Thomas and Heidi Wooley were a joy for the subjects' camaraderie, willingness to share fond memories and dedication to documenting German Village stories for future villagers.

For those German Villagers who read my columns weekly, I thank you for your enthusiasm, support, constructive criticism and contributions. To anyone I have overlooked, my sincere apologies. Finally, please accept that while I believe my research is thorough and solid, there are no doubt errors within the following text, the fault for which lies only with me.

History, Historic Preservation and Urban Renewal

German Village Architecture 101

German Village architecture is both distinctive and not. It is distinctive in that our neighborhood has a core of over one thousand buildings surviving from more than one hundred years ago that really do look much as they did when they were built. It is not distinctive in that, aside from our story-and-a-half cottage and Dutch Double, the styles really can be seen throughout the country.

The story-and-a-half cottages and Dutch Doubles are unique to the neighborhood and share the cultural history of those who settled here first. The German Americans who settled in Columbus brought little with them and were of meager means. The homes they built were practical and functional, not decorative or whimsical.

The homes had just the number of rooms and windows their occupants needed. The Dutch Double allowed for two families to co-own a home, thus alleviating some of the financial burden that plagued immigrants in the mid-1800s. These homes were in no way pretentious or ornamental, and they truly were a sign of the times. They are our most important structures because they are unique to our neighborhood.

Italianate and Queen Anne homes tell an entirely different story. They are larger, more decorative, showy and, at times, a little pretentious. Don't get me wrong, they're beautiful homes. But the story they tell is of the more affluent German Americans who called the South End home, those who came here

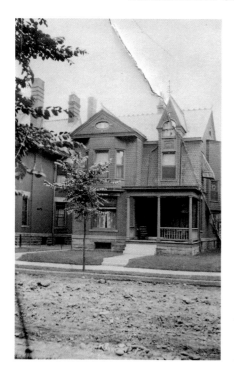

Left: No. 99 East Deshler Avenue, one of many Queen Anne homes on that street. Note that when this photograph was taken, Deshler Avenue was not yet paved. *Courtesy of the German Village Society Fischer Archives.*

Below: No. 766 Mohawk Street is a traditional German Village story-and-a-half cottage. *Courtesy of the German Village Society Fischer Archives.*

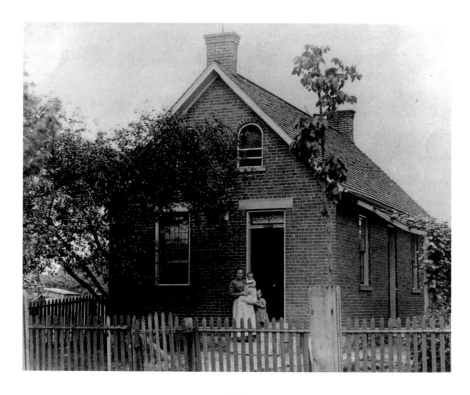

with more wealth or were more successful at the outset. Or perhaps these homes belonged to those who were able to take advantage of having a family already established here.

The time frame for construction doesn't overlap, so as you look at these homes you can tell which were built first. They generally go in order of size. The cottages and Dutch Doubles showed up around 1840 with the first German immigrants. The Italianates came along in the 1860s and the Queen Annes in the 1880s.

Here in German Village, our Italianate and Queen Anne homes are vernacular. According to resident Judith Kitchen's *Old Building Owner's Manual*, vernacular homes are considered popular architecture and pertain to architectural styles specific to a particular area, region or culture. So what is considered Italianate here will likely look a little different in San Francisco, for example. Major characteristics are the same, but implementation can vary.

The first Italianate houses in the United States were built in the late 1830s, and they were driven mostly by popular pattern books. The style immediately preceding Italianate was Gothic Revival, and by the 1860s, the Italianate style had completely overshadowed its predecessor. Italianate homes are vertical in nature, have a heavy cornice (where the walls meet the roof) and are most often made of brick.

Italianate architecture dominated American construction in the 1850s and 1860s (right about when the German American population of Columbus was gaining in both prominence and prosperity).

The panic of 1873 halted construction of Italianate architecture and made way for the whimsical Queen Anne homes that came with the return of prosperity.

From 1880 to 1900, Queen Anne architecture reigned over American building practice. It is decorative, elaborate, irregular and, quite frankly, spectacular. Many of the largest homes in German Village can be termed Queen Anne, and most of these are along Schiller Park. A good hint toward identifying a Queen Anne house is the fact that very few have smooth exterior walls; they're almost always "broken" or "interrupted" in some way.

The Italianate and Queen Anne homes in German Village are Columbus's variation on the styles. They carry the dominant traits and were built to be in vogue, but they were also built to suit the owners, many of whom were new to America.

So while I may think our cottages are our neighborhood's most dear structures, these larger, more dramatic homes are singular to German Village in that they continue to tell the stories that they were built to tell, and we can still so easily treasure their history today.

GERMAN VILLAGE HOMES AREN'T ALWAYS WHAT THEY APPEAR

Given the tremendous success our neighborhood has had with its Haus und Garten Tour, as well as all the other driving and walking tours that people take through German Village, I'd say that we've nailed how to make our houses look great during any season.

Whether due to landscaping, creative paint choices or just the simple beauty of orange bricks, German Village has its fair share of visual appeal and then some. But admittedly, a lot of that Old World appeal comes from the mature trees that line our streets and dot our yards and the warm patina that so many of our more than one-hundred-year-old houses have developed over time.

So how did the neighborhood's earliest residents achieve some much sought-after curb appeal in a neighborhood with then brand-new houses and freshly planted trees? Very creatively, that's how, and we're still reaping the benefits today.

Anyone who lives in one of the neighborhood's more high-style Italianate houses probably (hopefully!) treasures the decorated stone lintels that grace the windows. Usually floral in design, these etchings lend distinction to a popular and fairly common German Village house style. But have you ever noticed that the decorations only tend to be on the street-facing windows?

There's a reason for this. The early German settlers were really only concerned with what people walking down the street saw, and those people were really only looking at the street-facing side of the house.

The rationale was that the only people who would see the back and sides of a house were those who lived in it, and who needed to impress them? So the stone lintels above the windows on rear- and side-facing elevations usually remained unadorned.

The same holds true for the neatness of foundation stones. Next time you're out and about walking, take a look at the symmetry of the foundation

on the street-facing side of many German Village houses. Again, this was done to impress strangers or passersby.

Most foundations in German Village are made of rubble stones of different sizes, so symmetry was tough, but when at all possible, those foundations are fairly consistent when viewed from the street. It's when you look at the side or rear that you realize just how asymmetrical rubble stone really is.

Both of these techniques were done to project a sense of neatness and organization, something the earliest Germans in Columbus deemed very important. And no doubt, it spread resources further. I can't imagine the cost of etching a design into a stone lintel, but property owners must have saved money by only having the main building façade done.

Another way to impress one's neighbors was to build a home of cheap material and then give it an impressive and expensive-looking finish. A common way to do this was to use stucco, but an even more creative approach was to build a frame house made to look like stone.

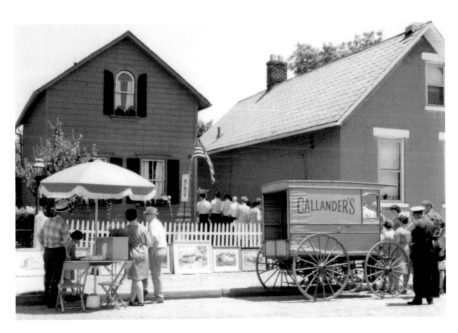

No. 628 Mohawk Street on the 1968 Haus und Garten Tour. No. 628 is a frame house, but note that the wood on the front was scored to look like stone. *Courtesy of the German Village Society Fischer Archives.*

I can think of three specific examples of this technique in our neighborhood, two on City Park Avenue and one on Mohawk Street. In each case, the houses were built of wood that was scored to have a stone ashlar appearance. Those early property owners who did this get extra points for tricking the eye and doing it on the cheap.

Of course, there are also brick homes that got face-lifts in the form of stone or fancier brick façades. This too was done to lend an air of distinction to the home without having to face the entire thing. The earliest German Villagers were nothing if not thrifty.

So always remember that there is more than meets the eye on every German Village street. Quirky surprises abound on each and every street, and they're definitely worth seeking out.

THIRD STREET'S "FOOTPRINT" HAS CHANGED LITTLE OVER TIME

I was planning to write this column in the form of a stroll down Third Street one hundred years ago. I was going to peruse my 1891 street map and see how our main drag has changed over time.

I quickly realized that this was a lousy idea for a column because Third Street has changed so little. Starting at Livingston Avenue, people walking down Third Street in 1891 would have hit a couple of saloons (today's Caterina Ltd. and the Book Loft), St. Mary Church with its looming spire, a shop and saloon at the southwest corner of Third and Frankfort (today's Max & Erma's) and shops at the northwest corner of Third and Columbus (today's Hausfrau Haven).

There were, of course, a few notable changes. No business was listed at the corner of Third and Livingston (today's Katzinger's), a small one-story shop abutted a double residence at the southwest corner of Third and Blenkner (today 515 South Third Street), a carpet weaver had a shop at 529 South Third Street (today a large house stands there), a doctor's office stood at the present-day site of a parking lot at the northwest corner of Third and Beck Streets and a saloon was at the southeast corner of Third and Columbus (today the residence at 101 East Columbus).

One thing's for certain: early German Villagers liked their saloons. There was one at 866 South Third, too (the Haban Saw building; it also housed

Louis Waldschmidt owned the blacksmith shop at 595 South Third Street and lived at 601 South Third Street. Today, the buildings house a restaurant and dental office, respectively. *Courtesy of the German Village Society Fischer Archives.*

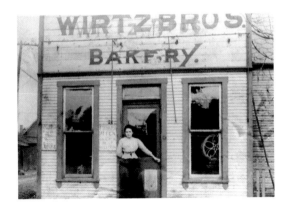

The Wirtz Brothers Bakery stood at 856 South Third Street, which is today 858–860 South Third Street. The building shown no longer stands. *Courtesy of the German Village Society Fischer Archives.*

a barbershop), so by my count, someone walking down Third Street from Livingston Avenue to Schiller Park had no possibility of going thirsty.

The map also shows a bakery at 580 South Third Street. The beautiful Craftsman house next door to the Meeting Haus today hadn't been built yet, and a smaller home with a bakery attached stood there instead.

A cigar/barbershop was at the corner of Third and Willow, where another beautiful Craftsman house stands today. Outdoor or summer kitchens dotted

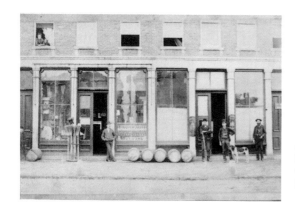

A saloon and apartments once housed what is today a gift and wine shop at 769 South Third Street. *Courtesy of the German Village Society Fischer Archives.*

the landscape to give those cooking relief in the warmer months. The idea was to take the heat from cooking outside, rather than sweat out everyone in a tiny brick cottage.

Smokehouses, bake houses, outhouses and slaughterhouses were scattered throughout the neighborhood, but I imagine they didn't always make good neighbors. Hay sheds and buggy sheds were scattered along many of the alleys, along with several wagon shops and even a baby carriage shop.

Fast-forward almost 120 years and you'll see a similar mix of residential, commercial and institutional use in today's German Village. Many of the commercial buildings still provide working space for wonderful gift and craft shops, restaurants, bakeries and pubs. Thankfully, St. Mary's and its looming spire still look after the neighborhood, and of course, the Third Street School is today's Golden Hobby Shop.

This is one of the things people love about living in and visiting German Village. Yes, we're a downtown residential neighborhood, but we also have some of the best commercial spaces in town just a stone's throw from our front doors.

We're so pedestrian friendly because not only are our houses beautiful and enjoyable to look at on a stroll, but there are also places to go. German Village itself is a destination, but there are a multitude of destinations within German Village. And how lucky for us that we live here and get to enjoy it every day!

So next time you're out for a stroll, ask yourself what that building used to be. A cobbler's? A blacksmith shop? A barbershop? Judging from the old map, the odds favor a saloon, but you never know.

And lousy idea or not, I managed to get a column out of taking a walk down a street that has changed little over more than ten decades. Only in German Village!

CELEBRATING THE FOURTH OF JULY IN GERMAN VILLAGE

When the German population of Columbus presented the monument of Friedrich Schiller to the city on July 4, 1891, a citywide parade and celebration were planned. The following is taken from the event program:

The Fourth of July is certainly the most appropriate day for the German Americans to celebrate the memory of Friedrich Schiller, the poet of Liberty,

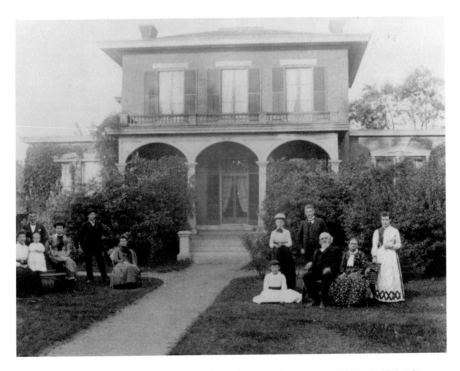

The Honorable Henry Olnhausen with his family at their home at 664 South Third Street in 1890. The Olnhausen homestead is no longer standing, and the administrative offices of St. Mary Church (the Burkley Center) now stand in this location. *Courtesy of the German Village Society Fischer Archives.*

The same structure shown in 1925 as the original high school for St. Mary School. *Courtesy of the German Village Society Fischer Archives.*

the idol of the people. His works are not the exclusive property of the German people. His "William Tell," "Don Carlos," "Fiesco," in fact all of his works, permeated as they are with the spirit of Liberty, belong to the whole world.

Is there a better place on the face of the globe than our beloved adopted country, for the erection of a statue of Schiller, a token of our devotion to independence and freedom, of our love and fidelity to the Union?

Such were the sentiments which animated the members of the Suabian Benevolent Society of Columbus when on August 15, 1886, at the dedication of their flag, the orator of the day, Judge Henry Olnhausen, proposed the erection of a monument in remembrance of Friedrich Schiller. Unanimously and enthusiastically this proposition was adopted. A committee was appointed, and all the German societies of Columbus were invited to join in this praiseworthy enterprise. They met with a hearty response, and the work was begun by soliciting subscriptions from the friends of the enterprise.

The Saengerfest, in 1887 interfered somewhat with the progress, and for a time actual preparations were abandoned. On July 4, 1888, however, a festival was arranged in the City Park, which turned out to be a success. Other festivals followed, the celebration of Schiller's birthday, a dramatic

performance under direction of Mr. Wm. Bach, the laying of the corner-stone on July 4, 1889, the dedication of the pedestal on July 4, 1890, a bazaar, arranged by the ladies, etc., swelled the sum already collected sufficiently to justify the closing of a contract with the celebrated foundry of F. von Miller, in Munich, Bavaria.

Although the festivals held and the collections made netted a goodly sum, it would not have been sufficient had not the several societies donated liberal sums from their treasuries. The Suabian Society donated $200, the Turn-Verein $150, the Humboldt-Verein $100, other societies from $25 to $50; the Breweries of Columbus $700, Mr. Fred. Jaeger $500, etc. With equal liberality the North German Lloyd offered to transport the monument free of charge to Baltimore, and the B&ORR transported it to Columbus, also free of charge.

The city of Columbus can boast of possessing the largest as well as the finest of all Schiller statues in America, a masterpiece of art, larger than the Chicago monument.

The monument, including the base, is 25 feet high; on three steps, each a foot high, stands a pedestal, 11 feet high, bearing the statue, also 11 feet high, or nearly double life size. The statue weighs 1,200 kilograms or 2,640 pounds, is of bronze containing 90 per cent of copper, and shows a beautiful golden splendor. It costs 12,500 marks, or $3,000. The pedestal, designed by architect Joseph Dauben, and executed in Concord granite by the sculptor, Charles Wege, both of Columbus, O., shows in front nothing but the word "SCHILLER," worked in relief, and on the reversed side the inscription: "Erected by the German-Americans of Columbus, and presented to the City July 4th, 1891." The total cost, including statue, pedestal, steps and iron fence, amounts to $6,500, all of which has been contributed by the citizens of Columbus, O.

The preparations for unveiling this monument on July 4th, have been made on a large scale, and the program covers nearly the whole day. Early in the morning, at about 9 o'clock, a magnificent parade of the German societies of Columbus, with bands of music, banners and many floats will march down High Street to the City Park, firing Japanese fireworks all the way.

The Governor, the Mayor, the City Council, Board of Public Works, the officers of State, County and City, have been invited to participate in

*the ceremonies, and have kindly accepted. At the City Park the unveiling
and presentation of the monument to the city will take place, with speeches,
music and singing of the festival cantata, composed by Mr. H. Determann
and Prof. H. Eckhardt, and executed by the combined singing societies of
Columbus. In the afternoon popular amusements for the children, music
and singing, etc., will fill the City Park with a happy, good-natured crowd.*

*Numerous societies from other cities will visit Columbus on this occasion,
in view of the liberal offer of all the railroads to reduce their rates for
round-trip tickets to half the regular fare.*

GERMAN NEWSPAPER PROVIDED IMPORTANT LINK FOR SOUTH END RESIDENTS

Long before today's daily newspapers, the German community in Columbus
enjoyed reading *Der Westbote*. Established in 1843 in an office on East Main
Street, the paper ran until the First World War and was instrumental in
connecting new Americans to their former homes in Germany.

Started by Frederick Fieser and Jacob Reinhard, the paper faced a rocky
beginning. The following is quoted from an interview with Fieser:

*In the summer of 1842, Jacob Reinhard came to Cincinnati to broach the
subject of starting a German paper in Columbus. I was acquainted with
Mr. Reinhard when he was the engineer of the National Road, between
Springfield and Columbus. The prospects were good, and so I consented.*

The first number of the Westbote *was issued on the second day of
October 1843. Columbus was in 1843 quite small, and the German
population not very numerous. You could count the German businessmen
on your fingers. Besides that, the Whigs were in the majority in both county
and city, and the establishment of a German Democratic newspaper was
therefore not an easy task.*

*The difficulties were not overcome for years; but when once the turning
point was reached, the improvement was rapid. The field of the* Westbote
*gradually extended into other states, and its influence steadily grew
stronger until, in many localities in the state, the paper was considered the
"Democratic Bible."*

The *Westbote* served as a critical information tool for the Germans who settled in Columbus and the South End. Families were able to connect with both their new and old homes. Individuals who understood only German had a link to stories about both here and abroad and were able to stay abreast of political and social topics.

This newspaper, which started as a weekly and then progressed into a triweekly and ultimately a daily, had a long and prosperous life from 1843 to 1918.

In that time, its readership came to rely on the paper for thorough and honest reporting, as well as a fair assessment of their own lives in the city's South End.

In 1855, the paper printed:

> *The people who live in these small houses work very hard. You will not find silver on the doors, but you will find many little gardens which produce vegetables for the city's market. You will not find silk or other very expensive things; but the houses are very clean, the people work hard and are very healthy, and they are very happy.*

Other than personal accounts, it is this description that gives us perhaps the best indication of what life was like in our neighborhood's earliest days. Prosperity, modesty and simplicity seemed to work best in the South End and provided German Village with a solid foundation for today and the future.

The *Westbote* folded in 1918 at the height of the anti-German sentiment raging through Columbus and other cities with large German populations. Its closing comment was one of respect for the United States, and editors reflected on the paper's allegiance to its "new" country during the war.

Der Westbote holds an important place in our neighborhood's history for the support and information it gave the city's growing German population. Its standard of communication helped create a prosperous and confident community in the South End that we continue to learn from today. The German Village Society is fortunate to own several original copies of the paper, and they provide wonderful learning tools for school groups that come in for tours. If you can read old German and have a desire to learn more about the life and times of the 1860s, feel free to stop in and take a look.

BASEBALL IN COLUMBUS HAS TIES TO GERMAN VILLAGE

Summer calls to mind one common national pastime: baseball. Columbus and German Village have a long and storied baseball history, and thanks to James Tootle's *Baseball in Columbus*, all of the facts, figures, statistics and history are assembled in one place.

Much like its arrival in other cities throughout the country, baseball got to Columbus just after the Civil War, more specifically in the early spring of 1866. The game branched out of the East Coast when Union, and eventually Confederate, soldiers rested between battles by playing the game. From there, the rules quickly spread when the veterans went home after the war ended in 1865.

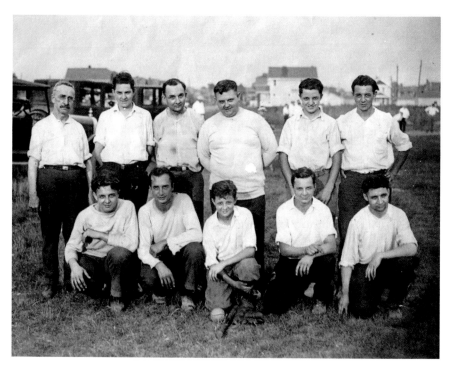

Alois Morbitzer and his ten sons after a baseball game at Recreation Park, where the Giant Eagle currently stands at the corner of Whittier and Jaeger Streets. This photograph was taken around 1929 and shows the following Morbitzers: *standing*, Alois, Edwin, William, Carl (aka Fatty), Richard and Leo (aka Scrappy); *kneeling*, Francis (aka Frank), Ewald (aka Ae), Joseph, Raymond and John. *Photo courtesy of Jeannine Morbitzer.*

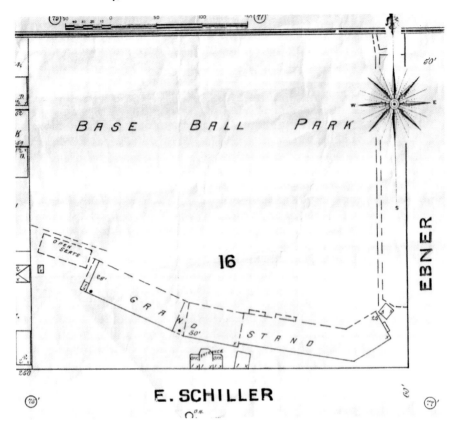

An 1891 Sanborn Fire Insurance map showing Recreation Park at the corner of East Schiller (today East Whittier) and Ebner Streets. Today, a Giant Eagle stands in this location. *Image courtesy of 1891 Sanborn Fire Insurance map and Sanborn Company.*

The first teams in Columbus were the Buckeyes, Capitals and Excelsiors; their respective club presidents were James A. Williams, James M. Comly and J.A. Neil. The earliest games were played on the front lawn of the "Lunatic Asylum," where I-71 meets Town Street today, and on the grounds at the corner of Cleveland Avenue and Long Street.

In 1866, when Allen Thurman and brothers W.G. and Daniel Deshler purchased Stewart's Grove, the future City Park and Schiller Park, Thurman's son Allen played on the Excelsiors, and W.K. Deshler played for the Capitals. How convenient that their fathers' new land was the perfect playing field. Tootle writes:

In July 1867, the Washington Nationals, one of the leading base ball clubs in the country, visited Columbus for a game with the Capital Club. Columbus was their first stop on a ten-game tour of six western cities. The game was played at City Park (today Schiller Park). Because of the Nationals' prominence, the event received considerable attention. As expected, the Nationals scored a lopsided victory, 90–10, but it was an exciting day for the city, and the traveling party of the Nationals praised Columbus for its good sportsmanship, hospitality, and the skill of its players.

(Incidentally, this game has been "replayed" by vintage baseball players in Schiller Park, and each summer the Ohio Village Muffins play vintage 1860s-style baseball throughout the state.)

Although 90–10 sounds miserable, other games on the Nationals' western tour had similar scores. The Nationals won 88–12 in Cincinnati, 88–21 in Louisville and 113–26 in St. Louis. All in all, it looks like the amateur Capitals held their own.

By the 1870s, baseball had become so popular that amateur clubs like those in Columbus had a hard time competing—in both games and attendance—with professional baseball teams. In 1874, former Capitals pitcher Jimmy Williams organized the Buckeye Club, a professional team that played near Union Station on North High Street and wore white uniforms with brown trim.

In 1881, the Columbus Buckeyes joined the American Association, baseball's first major league. Other franchises were in Cincinnati, Louisville, Philadelphia, Pittsburgh, St. Louis, Baltimore and New York. With Henry Chittenden acting as the Buckeyes' club president, the team finished sixth in the eight-team association, and the Philadelphia Athletics won the pennant.

Three years later, Columbus lost its major league franchise, but not necessarily for lack of skills or effort. At the time, the City of Columbus enforced blue laws that prohibited games on Sundays, the day most teams saw their biggest crowds.

In 1887 and 1888, Columbus fielded minor league teams that played at what was considered the new Recreation Park. The wood used to build this park was taken from the dismantled original Recreation Park that stood at the corner of Parsons and Mound Streets.

The new Recreation Park was constructed where the present-day Giant Eagle currently stands in German Village, and historic maps show the

grandstand to be a substantial and large structure. In 1889, when Columbus joined the majors once again, the park's seating capacity was increased to five thousand spectators. That year, Al Buckenberger was hired to manage Columbus's new team, the Solons.

The American Association closed its doors in 1891, and with that, professional baseball came to an end in Columbus and the South End. But it wasn't over entirely. In 1902, Columbus became a charter member of the new American Association minor league, and today, baseball in Ohio's capital city is still going strong, even without a stadium in German Village.

German Roots Not Always Appreciated in Today's German Village

On April 2, 1917, President Woodrow Wilson asked Congress for a Declaration of War against Germany, a move that would dramatically affect

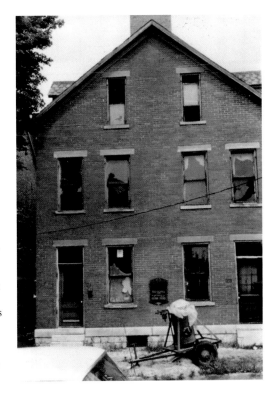

No. 574–576 City Park Avenue before restoration. Before reaching the dilapidated state shown here, this structure housed a saloon. According to a *Columbus Dispatch* feature article, the saloon owner, Joseph King, and his wife moved to Columbus from the duchy of Swabia, Germany. The Kings' saloon thrived for twenty-five years until it became a poolroom in 1908. Beer brewed at the Hoster and Schlee breweries was served, and German bands such as the Swabian Nightingales frequently played. This structure was originally built as a story-and-a-half cottage, but the roof was raised to provide upstairs living quarters for the King family. *Image courtesy of German Village Society Fischer Archives.*

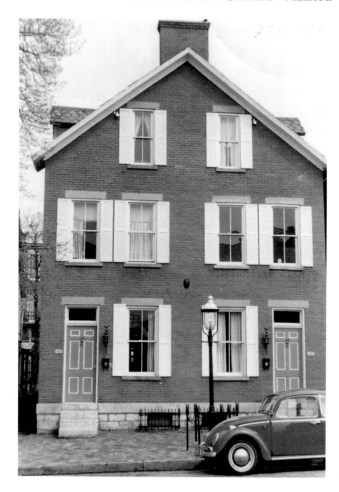

No. 574–576 City Park Avenue after restoration. The departure of so many residents from the South End left, in many cases, vacant houses or poorly maintained rental properties. With the 1960s movement toward restoration and the creation of the German Village Society, many structures were given a face-lift and a second chance. *Courtesy of the German Village Society Fischer Archives.*

the way of life for German Americans in our neighborhood and throughout the United States.

Here in Columbus, German Americans had been living prosperous lives in a largely German community just south of downtown. They were prominent socially, politically and financially. Their membership organizations (such as the Maennerchor) were highly regarded, and their conservative approaches to education were respected.

And though I don't know this for sure, I suspect that they didn't necessarily consider themselves German Americans as much as they did simply Americans. This was their home; they came here, grew up here and lived perfectly pleasant lives here.

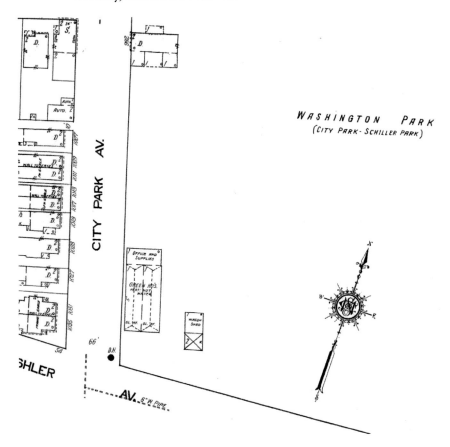

A 1922 Sanborn Fire Insurance map showing Washington Park, formerly City Park and then Schiller Park. Note also the original caretaker's home along City Park Avenue that predated the 1935 Works Progress Administration Caretaker's Cottage that stands near that location today. *Image courtesy of 1922 Sanborn Fire Insurance map and Sanborn Company.*

That is, until the outbreak of the First World War, which prompted incredible distrust of just about anyone with a drop of German heritage. And this was a lot of people, as many cities in the Midwest had large German populations. (It must be noted that thousands, perhaps hundreds of thousands, of German Americans showed their loyalty to the United States by serving in the armed forces during the war.)

In Columbus, street names were changed; Bismarck became Lansing, Kaiser became Lear and Schiller became Whittier. Schiller Park was renamed Washington Park, a handful of Schmidts became Smiths (and so

many others with German last names changed their names to sound more American) and German books were burned.

More importantly for our purposes today, the anti-German sentiment sparked by World War I prompted an exodus from our neighborhood. For people who were having a hard time simply being German, it couldn't have been easy to live in a place known for being German. While the neighborhood wasn't called German Village yet, the South End was known for its ties with Germany, and that made it a tough environment in the 1910s.

The German departure from the South End was a big move for a proud group of people, people who had previously been lauded for their contributions to Columbus. And while it was dramatic, it may not have been quite as dramatic as it sounds. Not everyone left. But the large numbers who did made their absence felt by those who remained.

City fathers noted the large absence of property owners in the South End, too, and three decades after their departure made plans for newer and better things for the neighborhood. But I move too far ahead.

After the United States got involved in the war, the same community hit hard by anti-German sentiment was hit by Prohibition, which resulted in all but one of the Columbus breweries closing. Many of the employees of the breweries were the Germans who lived in the South End, so the closings were effectively strike number two.

Then came the Depression, which hit this depressed group of Columbus residents particularly hard. Collectively, they were unpopular and not trusted, and by this point, many were already unemployed. The Depression only added to an already difficult situation.

And thus came the decline of the South End. Once those negatives added up, it was tough to move quickly toward the positive. And so it was that the city, in its zest for urban renewal in the 1950s, leveled the northern third of the village. The old traditional boundary of the South End went to Main Street, but today, Interstate 70 acts as a "natural" boundary.

This was the obstacle that the German Village Society's founders were up against when they thought to get the area established as a historic district to prevent more demolition. What a daunting job that must have seemed at the time! But they did it, and it worked, and now, fifty years later, we're stronger than ever and only moving forward.

Even though we don't hear much German spoken in the village, we walk the same streets and live in the same homes as those early German settlers, and we respect their history and contributions to the present. And we absolutely appreciate the German in German Village.

PROHIBITION MEANT HARD TIMES FOR COLUMBUS'S SOUTH END

Prohibition was, in a word, devastating for the South End of Columbus. One piece of legislation signed more than eighty years ago literally changed the face of our neighborhood and, in its own way, effected the changes that would take place in the 1960s that led to us becoming a recognized historic district.

The Eighteenth Amendment to the U.S. Constitution went into effect in 1920, and overnight it became illegal to manufacture, sell and transport alcohol in the United States. Initially, President Woodrow Wilson vetoed

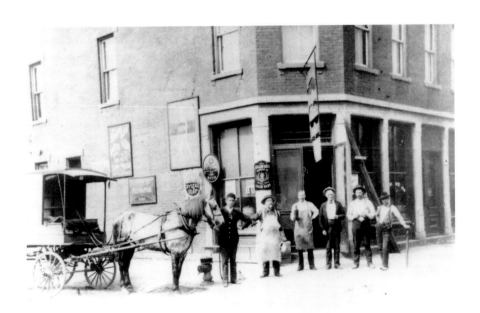

No. 169 East Beck Street (today Lindey's), pre-Prohibition. Note the Columbus Brewing Company and Born Beer signs on the front of the building. *Courtesy of the German Village Society Fischer Archives.*

the act, but Congress overrode his vote the same day. The Eighteenth Amendment was preceded by the Volstead Act, named for Andrew Volstead, chair of the Senate Judiciary Committee, who oversaw passage of the bill.

In large part, the effects of Prohibition were unexpected. Rather than have legitimate businesses oversee the production of alcoholic beverages, gangs took over, fighting for market control and creating a more violent climate that ultimately evolved into gangsters being treated like celebrities.

Local police were left to enforce Prohibition, but very often gangs became so wealthy and powerful that they were able to bribe local law enforcement officials, thus corrupting the system in every sense of the word.

Prohibited beverages became all the more enticing to the American public, so speakeasies prospered. All in all, people found ways around the Eighteenth Amendment.

Some of the people hit hardest by Prohibition were German Americans who owned or worked in breweries. Hundreds of South Enders were employed in Columbus breweries, and all but a few lost their jobs when the breweries were forced to close.

German Americans had voiced strong opposition to the Volstead Act en masse when it was under consideration, but the community was discredited by prejudices surrounding World War I, and because of that, their protests were ignored.

When brewery workers living in the South End lost their jobs, times were hard indeed. Many families left the area, making vacant properties abundant and absentee landlords major property holders. This, of course, led to the decline of the area and made it a prime target for urban renewal, aka the demolition of the northern third of the South End.

The Eighteenth Amendment was ultimately repealed, but in baby steps. In 1933, "3.2 beer" became available; it was 3.2 percent alcohol by weight (full-strength is up to 5 percent). This was a big baby step, however, in that, since 1920, only "near beer" (which was very nearly alcohol free) had been available to the drinking public.

At 12:01 a.m. on April 7, 1933, breweries had trucks ready at the gates to distribute 3.2 beer. Some even sent cases directly to the White House. Franklin Roosevelt had been in office for just one month, and his passage of the Cullen-Harrison Act to end Prohibition added to his already popular status.

The *New York Times* reported that the repeal of Prohibition created fifty thousand jobs during the Depression, but by 1933, the South End had been hit too hard and was a long way from recovery.

But as you know, the South End did recover, and in doing so, German Village became a locally and nationally recognized historic district. We honor our link to the breweries by highlighting that chapter of our history in tours, and we see a living testament to the breweries' strength in the Brewery District that remains today.

So celebrate our history, and feel free to toast the very good things that came to our neighborhood after such a difficult time for our predecessors.

German Village Roots Linked to Chancellor of German Empire and U.S. Secretary of State

By the 1870s, the German population in Columbus had become politically connected, well respected and, quite frankly, very large. Grand Italianate homes were being built alongside the older story-and-a-half cottages, German businesses were thriving and both St. Mary Church and the Ohio Statehouse were considered new buildings.

The city was still growing, and on the South Side, residents of Elm Street received new addresses overnight. In 1872, Elm Street was renamed Bismarck Street in honor of Otto von Bismarck, who one year earlier, in 1871, had been appointed chancellor of the newly unified German Empire.

Until 1871, Germany consisted of many principalities loosely bound as the German Confederation, and Bismarck, as a career politician, utilized his years of experience in negotiating such unification. Since the time of the Holy Roman Empire, kings had tried to unite the German states, but the plans never succeeded until Bismarck became involved.

Bismarck, who lived from 1815 to 1898, was very conservative in his politics and extremely cautious in his foreign policies. His friend and the king, Wilhelm I, rarely challenged the chancellor's decisions, and in fact his position in the government was so secure that on several occasions he obtained Wilhelm's approval by threatening to resign.

Like any successful politician, Bismarck was calculating, and this trait saw both negative and positive results. When Bismarck was orchestrating the

unification of the German states, he intentionally excluded Austria in order to make Prussia the most powerful and dominant region in Germany.

Much of Bismarck's work was undone when Wilhelm II, grandson of Wilhelm I, ascended the thrown. Not a peer of Bismarck like the former emperor, Wilhelm II was forty years his junior and more interested in rapid expansion than in the experienced chancellor's slow approach to strengthening the German Empire. Some historians go so far as to argue that the second Wilhelm's arrogance alienated and united other European powers against Germany in time for World War I.

For Bismarck's efforts and successes, he is remembered in monuments throughout Germany; he has cities, towns and ships named for him; and, here in Columbus, his legacy survives as Lansing Street.

That's right. Although Elm Street was named Bismarck Street in 1872, it was changed again in 1918 due to the strong anti-German sentiments so popular among American-born residents during World War I.

Robert Lansing was the United States secretary of state under President Woodrow Wilson from 1915 to 1920—a very powerful American, indeed, at a time when America was fighting in World War I.

Born in 1864, Lansing's lifetime overlapped that of Bismarck for about three decades. Lansing advocated "benevolent neutrality" during World War I, although he eventually supported the idea of American participation. No doubt, for many Columbus residents, honoring a true American like Lansing allowed for a better night's sleep than honoring a true German like Bismarck.

And while Lansing may indeed have been a great American, deserving of a lasting legacy in the form of a street name, let's not forget the other individual so honored, for Bismarck meant as much, if not more, to the German American population as Lansing did to the Americans.

How German Village Was Saved in the Name of Progress

It is remarkable how progress and time can change a neighborhood. Sanborn Fire Insurance maps reveal extraordinary information about the historic footprints of structures in German Village, and in just the few years between

1887 and 1901, our neighborhood's forefathers witnessed an incredible boom in construction.

Take Stauring Alley for example. Doesn't sound familiar? Stauring Alley no longer exists, however much of its footprint is still traveled.

Stauring sat between Fulton and Livingston, where Interstate 70 lies today. It was one of those weird thoroughfares that was part alley, part street, in that it had outbuildings belonging to Fulton Street properties, as well as dwellings and larger structures. I suppose we can liken it to Macon Alley today.

Perhaps the biggest business in 1887 on Stauring Alley belonged to Charles Gutheil, contractor and builder. Mr. Guthiel's home was located at 339 East Fulton Avenue, and his business was behind the home and extended back to Stauring Alley. A mill and a lumber shed were on-site, and adjacent to the property were three double residences. The commercial buildings are labeled "A" and "B" on the map, and the doubles are marked "C" through "H," so it seems likely that these were employee housing. Each double was a story and a half. My maps aren't crystal clear, but based on the address, I think this business was close to Grant Avenue.

Moving farther west, Stauring Alley was an address for many residences between Fourth and Fifth Streets, and it is at this location that Donaldson Street appears and travels straight east–west where Livingston Avenue slants southward.

The blocks between Fourth and Fifth were cut by Zettler and Schreiner Alleys, an address for large two-story houses, shops and, perhaps most notably, the German Grammar School at the northeast corner of Fourth and Fulton. Further adding to the book-smarts of South End residents was Columbus's Public School Number 5, which stood just north of the German Grammar School.

Today, that site still belongs to the Columbus Board of Education, and across the street is the City of Columbus Fire Department.

Even farther west sat the building that I find most interesting. Directly across Livingston Avenue from what is today Katzinger's Delicatessen was the German Methodist Church. This institution kept holy company with St. Mary of the Assumption Catholic Church and Trinity Lutheran Church.

The church was demolished in 1966 to make way for the Interstate, and shortly thereafter, the congregation moved to its newer, more modern building at Livingston and Mohawk.

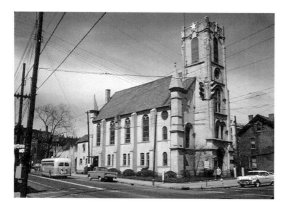

Livingston Methodist Church, Third and Livingston, early 1960s. This block and several other blocks north were considered part of the German South End and created a seamless transition into downtown Columbus. These several blocks were demolished to make way for Interstate 70. Today, a small park is at this location near the ramp over the interstate. *Courtesy of the Columbus Metropolitan Library.*

My 1887 Sanborn maps also show just how much Columbus was growing and just how large the German neighborhood was. At the southeast corner of Mound and High, the foundation was laid, and the Franklin County Courthouse was in the process of being built. Just across the street on Mound was St. Paul's German Church; today, the Franklin County Hall of Justice, Courthouse and Jail stand on the site.

Just a bit east of the early courthouse foundation was St. John's Church, which, thankfully, still stands today. Of all the buildings mentioned above, all we have left to join St. John's is St. Mary's, Trinity Lutheran and, of course, Katzinger's.

A quick online search for information on Stauring Alley led me to a site hosted by the Columbus Jewish Historical Society. Stauring Alley is mentioned several times, and at the end of the street was a Jewish settlement house. Stauring ran from Pearl to Washington, and although I can't be certain where the house stood, an individual who grew up on Stauring mentioned on the website that these were "thoughtful German Jews who bolstered us and encouraged us to learn how to live an American way of life."

So next time you drive downtown into German Village, think about how our neighborhood used to extend north. Think of the homes, shops, industries, churches and synagogues. Think of all the buildings that used to face those still standing on the south side of Livingston Avenue. And think of how lucky we are that German Village was saved from "progress."

CELEBRATING "RESIDENCE AS DISTINCTION" EARLY AND OFTEN

In the German Village Society's golden anniversary year, we are taking plenty of time out to celebrate our accomplishments, our history and our plans for the future. The Society's birthday is January 10, and while we don't celebrate it every year, we are making a point to make 2010 a year of big celebrations in German Village.

To explain the impetus of our organization, it might be best to share an article printed in the *Dispatch* in 1959, titled "Urge Restoration of South Side German Section to Beauty" and written by early friend of the Society Jenice Jordan:

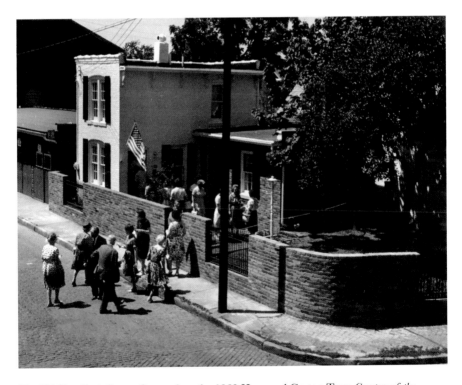

No. 121 East Beck Street, featured on the 1963 Haus und Garten Tour. *Courtesy of the German Village Society Fischer Archives.*

The South Side's old German section should be restored to beauty—not allowed to deteriorate—according to native Columbusite Frank Fetch.

Restored, its flavorful character would be to Columbus what Georgetown is to Washington, D.C., or Greenwich Village to New York.

Mr. Fetch, his wife and her father, Harry Royse, all of 4136 Cherry Road, are advocating the restoration as avidly as they know how—by putting their own money into the project. They've already renovated three houses in the area, the latest at 767 Wall Street. And they are working to snowball their idea into the formation of an association.

Mr. Fetch suggests that civic leaders join forces to buy the old houses as they come on the market, remodel them and sell or rent. An alternative would be for individuals to champion the cause by working as the Fetches and Mr. Royse are.

This campaign started back in 1943 when, "just to have something to do and to create an income for the future," they turned a corn-crib on Columbus Street into a just-for-two cottage.

They chose the German section, Mr. Fetch says, because of "a keen feeling for the area; its architectural atmosphere is entirely different from anything else in Columbus.

"Around Frankfort, Kossuth, and Mohawk Streets," he continues, "the architectural atmosphere hasn't changed in more than 100 years except that descendents of the original families have moved to newer sections of the city and the beautiful old homes have been allowed to deteriorate."

Should an association be formed to restore the area or if individuals took interest in the project simply to create their own future income property, Mr. Fetch suggests that the remodeling needn't be elaborate—"just return the houses to their original state."

This result could rival what's happened in the Georgetown or Greenwich Village areas where residence is considered distinction. And the City of Columbus would benefit financially, too, Mr. Fetch points out, from the increased tax value of an improved neighborhood.

As the Society looks its fiftieth anniversary square in the eye, it's clear that Mr. Fetch may have been wise beyond his years. Thank goodness for his foresight!

German Village Shows Its Strength in Numbers

The German Village Historic District—the key word being district—embodies a significant time period, community and feeling in its architecture. Our neighborhood truly is a case in which the whole is greater than the sum of its parts.

Properties listed on the National Register of Historic Places are distinguished as having been documented and evaluated according to uniform standards put forth by the National Park Service and upheld by the State Historic Preservation Office.

These standards deemed our neighborhood "historically significant" in 1974, when it was listed on the National Register, and those same standards are being maintained more than thirty years later by review bodies like the German Village Commission.

The long and the short of it is this: our greatest strength lies in the fact that we are a district.

The likelihood of one of our structures being listed individually on the National Register in 1974 was, quite frankly, pretty slim. The National Park Service maintains the National Register, and its criteria are the following:

A structure is associated with events that have made a significant contribution to the broad pattern of our history, or is associated with the lives of persons significant to our past, or it embodies the distinctive characteristic of a type, period, or method of construction that represent the work of a master, or

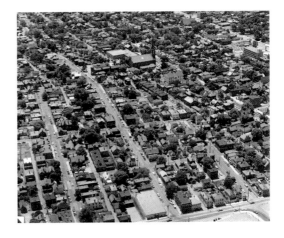

Bird's-eye view of German Village, particularly Mohawk and Third Streets, taken in the 1960s. *Courtesy of the German Village Fischer Archives.*

it has yielded or may be likely to yield information important in prehistory or history.

First criteria: While it is absolutely true that our neighborhood is associated with events that made a significant contribution to the broad pattern of history (German immigration to the United States, for example), no one building can really claim that; certainly not little old 588 South Third. But if we're talking about the entire district, it's a different story.

Second criteria: German Village is definitely associated with the lives of persons significant to our past, but I think we can all agree that this association is at a local level. Granted, prominent German Americans lived in this neighborhood, but the vast majority of people who made their lives here were ordinary people like you and me. That fact is reflected in our architecture, and it is something we should be proud of. High-style architecture may be jaw-dropping, but it is rarely described as quaint, charming and comfortable.

Third criteria: The "quirkiness" of our buildings is endearing; if we didn't all agree, we wouldn't all like German Village as much as we do. That being said, "quirky" architecture is rarely, if ever, associated with the work of a master architect. Again, one of the things that makes German Village distinct is how comfortable the neighborhood feels.

However, our streetscapes do nothing if not embody the distinctive characteristic of a type, period or method of construction. But it takes a whole streetscape (or at the very least, a whole block) to do that here. It really can't be done with any one story-and-a-half cottage or two-story Italianate.

Fourth criteria: Sure, German Village might make huge contributions to prehistoric information someday, but heaven help the preservationist or tourist walking down our streets who thinks about fossils before beautiful brick buildings, fail-proof architecture and the thrifty ways of early immigrants!

So you can see that being listed on the National Register of Historic Places demands specific criteria that can be difficult to meet. The good news is that none of us needs to meet those criteria—we've already done it.

There are two important roles to play in composing a National Register district. Some buildings will be pivotal to the significance of a district, and others will simply contribute to the district's historic sense. What's most important to realize here is that these two roles get equal billing.

It's on our dollar bill, and it was one of our earliest national mottos: *E pluribus unum*, or "Out of many, one." Considering the big picture, comparing our historic district to the nation at large might seem ambitious, but I think it's a great way to describe the German Village Historic District.

Our district is eighteen hundred structures strong, and that is, without question, something to be proud of!

A LESSON IN PRESERVATION LINGO AND OLD WORLD HISTORY

Reduce, reuse, recycle—it's a mantra we all know and love. While this saying is usually reserved for bottles, cans and newspapers, it works for buildings, too; only in this case, it is called "adaptive reuse." I like to think of it as one of the very foundations of historic preservation.

An obvious objective of the preservation of buildings is to retain a piece of our collective history for future generations to learn from, use and enjoy. Architecture acts as a visual recollection of our past, on both a large and small scale. Remembering this past by keeping buildings intact allows for a continuity of tradition and a sense of place.

So, getting back to recycling, why build something new when you've got a perfectly good older building? Who says a building is only built for one purpose? Why not reuse a building to meet contemporary needs? In other words, why not recycle it?

Adaptive reuse is exactly what it sounds like—reusing a building for a new or different purpose. Like using a warehouse for loft apartments, a school building for a bank or a Woodsmen of the World lodge for a Meeting Haus.

An interesting example of this in German Village is the building at 555 City Park Avenue. Most locals remember it as the site of the Old World Bazaar.

The building at 555 City Park Avenue was built sometime between 1891 and 1901. Streetcars were used in Columbus as early as the 1860s, but I'm guessing they surged in popularity in those ten years because, by 1901, 555 City Park Avenue contained one large building that covered the whole lot from City Park to Pearl and served as the Columbus Street Railway Company's car barns.

By 1922, the building was the Columbus Railway Power and Light Company Garage, serving a similar purpose but also a clear sign of the times. Rather than provide space for horse-drawn streetcars to be stored at night, the building now marked how modern Columbus streetcars had become.

In the 1950s, the building housed Walker's Car Wash, one of the first automated car wash facilities in the area.

In the 1960s came the installation of the Old World Bazaar at 555 City Park Avenue. Described in a 1966 *Spectator* article as "an arcade of shops on three levels which is currently the 'talk of the town,'" the Old World Bazaar brought unique gifts and wares to German Village in its earliest days as a renewed community.

Interestingly enough, the 1966 article stated that "with leases available only to those who too share the Village concept of combining the best of the 20th century with the charm of a world passed by, a unique gem has been added to German Village."

Early shops were Inez B. Williams Florist; the Eagle's Nest, which sold unusual antiques priced from "very reasonable to outlandish"; the Squire Ltd.; and Juergen's Konditorei, owned by Juergen and Ursula Klimke.

For about a decade, the Old World Bazaar attracted shoppers and no doubt helped attract visitors to German Village. To me, it seems likely that these shops probably worked best in an old building. Anything called an Old World Bazaar would have had quite a different feel in a contemporary 1960s building.

Today, the building at 555 City Park Avenue is used for office space, and because of that, it still maintains the tradition of adaptive reuse. The building has received lots of little touches over the years, and some of its most historic architectural features are gone, but you can still see quite a bit of its history.

Take a walk by this building and look above the bay window on the City Park façade. You'll see an arched row of bricks and a straight row of vertical bricks standing below. These features indicate old window and door openings. This unique building has seen lots of changes in its history, but what counts most is that those changes occurred.

As an alternative to demolition, old buildings can usually present lots of creative options for future use. As residents of a historic community,

this is common sense to us, but it's an idea that's still gaining strength in many places.

So continue to reduce, reuse and recycle, and think big when you do it. Anyone who gets to enjoy our buildings in the next one hundred years will thank you for it!

NEWER HOMES BREAK THE GERMAN VILLAGE "MOLD"

When people think German Village, they generally recall small brick cottages or large brick Italianate- and Queen Anne–style homes, and while this isn't a bad thing, we've certainly got more to offer.

Haus und Garten visitors at the intersection of Beck and Fourth Streets. *Courtesy of the German Village Society Fischer Archives.*

The 2007 Haus und Garten Tour was unique in that it offered several different architectural styles that one doesn't often associate with German Village (but probably should). In a word, the structures that don't fit our traditional mold are one thing: new.

Some are newer than others, and bear in mind that in a neighborhood with structures more than 150 years old, the word "new" holds an unusual definition. For instance, a house built in the 1920s is, in many ways, considered new here.

One house in particular exhibits Craftsman or Bungalow features. Though there is some debate as to its actual age, 604 South Third Street is, without question, heavy on the Craftsman details.

Bungalows were popular in the United States from about 1900 to 1930. Definitive features include a broad front porch usually supported by heavy square or tapered columns, a front-sloping roof sweeping from the main house over the porch in a continuous line and dormer windows in the center of the roof facing forward.

I took that description from a book because it would be difficult for me to come up with something better for 604 South Third. Talk about being a poster child for an architectural style!

About the same time that Bungalows gained in popularity, a more utilitarian structure did the same: the garage. Granted, a garage isn't really an architectural style by any means, but its place in architectural history is still important. After all, millions of Americans wouldn't have needed garages if they weren't buying automobiles, right?

The garage at 185 East Columbus Street is utilitarianism at its best. Making no attempts at stylized or decorative architectural features, the concrete block garage structure made clear exactly what it did: service automobiles.

Although a smaller, older structure stood at the corner of Columbus and Macon long before the existing building, the garage as it appears today took shape sometime between 1922 and 1951—coincidentally, the peak automobile purchasing years in the United States.

This mechanics' garage was built to service other automobiles rather than to house the automobile of one specific owner. For this reason, it didn't need to be decorative, architecturally distinct or even attractive.

But in its own way, it's all three of those things. It's decorative in the sense that artist Donna Burns has made the space a locally known and respected

artist studio, architecturally distinct in that similar garages in German Village are unfortunately becoming few and far between and attractive in that it stands out on the street as being both different and interesting.

Finally, there was a whole cluster of new homes on the 2007 tour, but where I referred to the above 1920s properties as new, I mean "new" here in an entirely different sense. These houses are 1990s new.

Built to respect and complement the historic structures around them, the properties at 629 Jaeger, 292 Lear, 284 Lear, 614 South Sixth and 615 Jaeger offer a unique cluster of distinctive design and new architecture. And they aren't even the freshmen in this year's tour class; the Truberry House at 639 Mohawk Street is twenty-first-century new.

These brand-new homes offer a unique perspective in our historic district and showcase creative ways to build new among old.

While every house on the 2007 tour was unique and beautifully maintained, these newer homes offered guests the opportunity to see something unexpected in German Village. We wouldn't be who we are without our story-and-a-half cottages and larger Italianates and Queen Annes, but in German Village, there is always more than meets the eye. Guaranteed.

THIS TIME OF YEAR, GERMAN TRADITIONS ABOUND

For several years, I have been asked to attend a wonderful opening ceremony of sorts at St. Mary School that involves lots of well-wishing for the first grade students about to embark on a momentous endeavor.

The ceremony is to welcome the first graders into what is the beginning of their formal education. Each grade welcomes them in their own way—with songs, puzzles, poems, you name it—and they wish the first graders luck in what will undoubtedly be a memorable year (for the parents anyway).

All of this surrounds the Schultuete, or "school cone," that each first grade student receives.

It's a German tradition dating to the early 1800s, and St. Mary's adopted it several years ago under the leadership of fourth grade teacher Mrs. Cotter.

The idea behind the Schultuete is to add sweetness to the first day of school and alleviate any nerves or concerns about being a "big kid" while celebrating the importance of education.

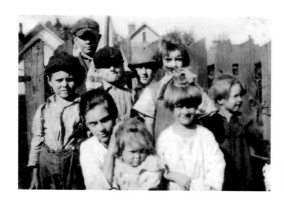

Gygax family children. *Courtesy of the German Village Society Fischer Archives, Gygax Collection.*

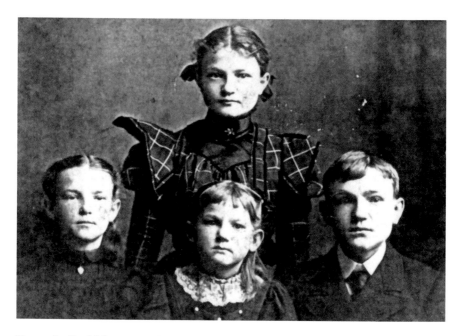

Knapp family children, 1897. *Courtesy of the German Village Society Fischer Archives.*

The Schultuete is a cone-shaped gift that's filled with sweets, toys and other goodies, all secured for the new students to open. Incidentally, the cones are nearly as big as most of the kids.

Each first grader is presented his cone and then marches off to have his photo taken, all under the watchful eye of the older students, who have imparted their sage advice on what it's like to be in school.

Some tips from the second graders—those arguably the most knowledgeable since they were most recently in the first grade—were "listen to your teacher" and "you'll miss your friends at the end of the year." Invaluable indeed!

The ceremony ends with the kindergarten students hanging tiny Schultueten on the Schultueten Baum (think Christmas tree) to nurture them and watch them grow throughout the school year. Then, when they've grown completely, its time for them to be picked on the first day of school next year.

It's a ceremony that brings German culture into an environment already heavy with German history and tradition. St. Mary's students learn very early (literally on day one) about a bit of German heritage and will carry that with them throughout their time in German Village.

And you thought Oktoberfest was the only German celebration in town!

GERMAN VILLAGERS

In giving scavenger hunt tours to students, my standard—and here abbreviated—story about why German immigrants chose to live in Columbus is this: war and famine prompted thousands of German families to leave their familiar homes in search of better opportunities in the United States.

As many of these Germans did not own the land they worked, they sought new cities and towns to establish themselves and start fresh. The National Road and canal system made Columbus easy to get to, and its status as a new city made it appealing to Germans interested in making their marks in a new land.

Many immigrants passed through New York City first but opted to move westward because an established city was just that—established. The Germans and other Europeans who ultimately settled the Midwest had visions of leaving a footprint on a new landscape rather than blending in to the hustle and bustle of an already thriving city.

I know this information to be true, and I try to explain it as easily as I can while keeping the very short attention span of your typical third grader. But recently I received a family history that supported this information firsthand and provided personal information that fleshed out the story a bit.

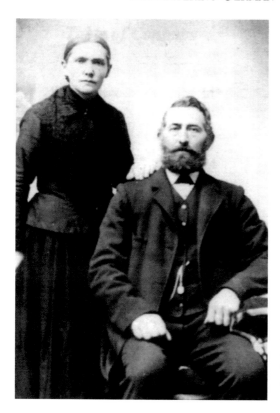

Pauline and Jacob Eilbert
brought their family from
Germany to Columbus in 1883.
The Eilbert family lived at no.
67, today 223, Jackson Street.
Courtesy of Dick Eilbert.

An Eilbert Family Chronicle, recorded and written by Richard L. Eilbert of Alexandria, Virginia, describes the process his family faced in their move from Germany to Columbus in 1883. Mr. Eilbert's family ultimately settled down at the corner of Fifth and Jackson, and his account provides a fascinating look at what German Village was like for its first generation of residents.

Since I'm not sure I can do it any better, I'd like to share some of Mr. Eilbert's work here to impress on the reader the resilience and perseverance our predecessors faced in their decisions to settle in a very young Columbus, Ohio:

> *Between 1815 and 1860, five million Europeans immigrated to America, and between 1860 and 1890, another 10 million came. By 1890, the United States played host to nearly 2.5 million first-generation immigrants from Germany, and half of these German-Americans lived in just five states: Illinois, Michigan, Missouri, Iowa, and Wisconsin.*

Immigrants poured across America's shores looking for a fresh start in this vast land. And such were the expectations of the Eilberts in 1883 as they left the old world behind and headed for a new life in Des Moines, Iowa. Jacob and Pauline Eilbert, along with their 8 children and 11 other relatives left Bremen, Germany that June with plans to land in New York City and move to Iowa where relatives had already rented homes for their use.

After 13 days at sea and just before the Eilberts reached New York, Jacob told his family about a letter he had received several weeks earlier from a relative in Iowa. The letter reported that the economic situation in Des Moines was not good, and that Jacob and his family should not make that their final destination as they would never find work. Rather, the relative advised Jacob to stay in New York.

At this time, New York was far from the ideal destination for immigrants. The following contemporary description comes from Oswald Villard: "The filthy and unlighted streets were so unsafe after nightfall that no well-dressed woman dared to go out alone…the docks and the waterfront were dreadfully rundown, and the horrible slums through which ocean travelers drove to reach the inadequate hotels…made a dismal and discouraging impression upon all foreigners." Crime was rampant throughout the city, and murders were ten to thirty times more frequent in Manhattan as in European countries like Britain, Germany, and France.

Jacob made the easy decision to pass quickly through New York. Upon the advice of a friend who had settled in New York before Jacob arrived, the Eilberts moved to Marion, Ohio to join another German family who recently settled there. When they arrived in Marion to find no opportunity for work, the friend-of-a-friend recommended that they move on to Columbus, a good sized city at that time that could likely offer employment opportunities for Jacob and his sons. Jacob was given the names of several families who had already settled in Columbus, and the next day, the Eilberts took the train to Columbus.

Sure enough, Jacob's sons found quick work with the Hoster Brewing Company, and the family settled in two rented rooms in the basement of a Jackson Street home.

THE EILBERT FAMILY COMES TO COLUMBUS, PART 2 OF 2

When we last left the Eilberts, Jacob and his family had left Marion and settled into rented rooms in the basement of a Jackson Street home in Columbus. Jacob worked his trade as a carpenter, and his sons worked as bottlers at the Hoster Brewing Company.

For two months, Jacob, Pauline, their eight children and one nephew lived in two cramped basement rooms on Jackson Street. All eleven of them slept on the floor. Jacob found a small house to rent on Jackson Street next to Doelker's Grocery (which stood at the corner of Fifth and Jackson), and while they lived there, Jacob searched for more permanent housing. In 1884,

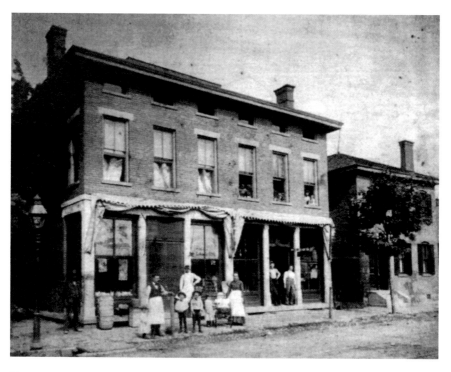

Nos. 537 and 533 South Fifth Street, 1890. This photograph shows Doelker's Grocery and Saloon at the northwest corner of Fifth and Jackson Streets. The Doelker family lived in the house next door, currently 533 South Fifth Street. The Eilbert family lived catty-corner, at the southeast corner of Fifth and Jackson Streets. Note the dirt street, gas lamp, awnings and tenants peeking out of upstairs windows. *Courtesy of Dick Eilbert.*

a house catty-corner across the intersection of Fifth and Jackson came up for sale, and on April 12 of that year, Jacob purchased it. The address was 67 Jackson Street. Today, the address is 223 Jackson Street.

Jacob purchased the small home from William and Katherine Reinhard. The house was one and a half stories and had just five rooms. Here, Jacob's trade in carpentry came in handy, as he added a full second story and a new kitchen to the house soon after moving in.

Later that year, Pauline became pregnant, and on March 18, 1885, she gave birth to the couple's youngest son and their only child born in America, Gustav Julius Eilbert.

In 1886, Jacob and Pauline's oldest son, Rudolph, who had left Hoster Brewing Company to work as a baker, planned to celebrate his third anniversary in the United States by going swimming in the Olentangy River at the iron King Avenue bridge. He and his cousin Wilhelm were to meet friends for the swim, but tragically they both drowned.

Both Jacob and Pauline were traumatized over the death of their oldest son, but Pauline took it particularly hard. When she died five years to the day later, family legend concluded that she died of sorrow over the death of her son and nephew. The Eilberts' youngest son, Gustav, was just five years old at the time.

In 1888, as tensions were mounting throughout the United States for non-American citizens, Jacob and all of his children under the age of twenty-one became naturalized citizens.

Standing in the Probate Court of Columbus, Jacob "renounced and abjured all allegiances and fidelity…particularly to William Emperor of Germany whose subject he has heretofore been…to become a citizen of the United States of America…entitled to all the rights and privileges of a naturalized citizen."

As the nineteenth century drew to a close, Jacob's sons Herman and Karl continued to work as a brewer and bottler, respectively, at Hoster's Brewery. When their younger brothers Wilhelm and Julius came of age, they too took jobs at the brewery.

In 1899, Gustav completed his catechism in German and was confirmed at St. John's Evangelisch Lutherischen Kirche (Evangelical Lutheran Church). He completed his primary education at the Third Street School (today the Golden Hobby Shop) and soon afterward took a job at the

Weiman Machine Works, allowing him to provide much of the financial support in the Eilbert household.

In the early 1920s, Gustav, or "Gust," began dating Alma Doelker, the youngest daughter of the Doelker family, who owned the commercial building catty-corner from the Eilbert home at Fifth and Jackson. The Doelkers' property consisted of a private home and a commercial building that contained a grocery store, a saloon, a stable and several second-story apartments.

Alma's father, John, had enlarged the family's residence and built the commercial building sometime in the 1880s. Gust and Alma moved to Washington, D.C., after their marriage, as Gust had been working there for the Bureau of Ordnance to the Office of Engineers for Rivers and Harbors.

The couple had two children, Virginia May and Richard Lyle. It is Richard's research and documentation that makes knowing this family's history and their accounts in German Village possible.

Although not every family is lucky enough to know so much of their history, the stories that Richard documented have added tremendously to the house files I keep on every property in German Village. Knowing of the Eilberts' journey, joys and sorrows has made the corner of Fifth and Jackson seem richer, and it goes to show just how much history our neighborhood has to share.

Scrapbook Offers Self-Portrait of Nineteenth-Century Politico

One cold winter week, volunteer Heidi Wooley and I spent several afternoons looking through about thirty old books—Heidi reading aloud, and me scribbling, very quickly, everything she was saying—in order to start a catalogue of what could be most useful for the German Village Society.

The toughest thing for me to handle is our collection of old books. Most are in German, and at best, I can recognize that *Die Bibel* means "The Bible." For someone who took four agonizing years of high school Spanish, German is no walk in the park.

Enter Heidi Wooley, a native German speaker and German Village resident extraordinaire who was born and raised in Germany. And while I

find her personality charming and her stories interesting, for purely selfish reasons I find her ability to read German very handy.

One of the more interesting things we found was only partially in German; it was a scrapbook kept by Alexander W. Krumm from 1879 to 1881, and it contained page after page after page of newspaper clippings from an assortment of Columbus papers.

From what I can gather from the scrapbook, in 1879, Krumm was unanimously nominated to run for the position of city solicitor, or chief attorney for the City of Columbus, and won that position. Krumm was a Republican, although his party affiliation and loyalty were debated in the newspapers. The articles in Krumm's scrapbook are from both English and German papers, and even though I can only read the English editorials, I can tell that opinions of Krumm were across the board, to say the least.

The *Journal*, a newspaper that supported Krumm, published the following in February 1879:

> *Alexander W. Krumm, our candidate for this office, is a lawyer of recognized ability, and while yet a young man—enjoys an extensive and lucrative practice…His spotless character, close application and careful fidelity to his clients has gained for him the entire confidence of the people, and he stands today a man of mature judgment and an honor to his profession, into whose hands the city can safely place its legal affairs.*

One month later, the *Democrat* published the following:

> *Mr. A.W. Krumm is the candidate of the National Party for City Solicitor. He is also the Republican candidate for the same office…This gentleman, of many political minds, must also be a Democrat, for the poll books of the Fourth Ward show he has been a regular voter at the Democratic primaries…Can't some one organize a fourth party for the benefit of this consistent gentleman?*

Regardless of his political persuasions, Krumm was a prominent, if not contentious, local figure, and today, his home at 975–979 South High Street is listed on the National Register of Historic Places for both its architectural and political significance. From a quick search, I learned that Krumm was

born in 1850 and died in 1910, and for all I know, he may have spent all of his life in the South Side.

What I find most interesting about the earliest articles mentioning Krumm are the references to his membership in the National Party. I don't know much about it, but thanks to a tip from Heidi, I think it must have been like the Know-Nothing Party of the 1850s, a group with nativist leanings that cropped up in response to the swelling number of Irish immigrants to the country.

Columbus and the Midwest became home to so many thousands of European immigrants that I can't help but be interested in conflicts that may have arisen between earlier Columbus settlers and among immigrants from different countries throughout Europe. It's a period in U.S. history that I don't know nearly enough about, but I think that a firsthand account like Krumm's scrapbook is a good place to get started.

How One Person's Small World Can Shape a Community

One week, I knew I had a good column idea when two Meeting Haus volunteers suggested that I write about Monsignor Burkley, an outright institution within St. Mary Church and School.

However, in order to best place the legacy of Monsignor Burkley in context, a little information about his parish is necessary. In the mid-1800s, Columbus's first Catholic church, Holy Cross, was becoming too crowded, and two new Catholic churches were established: St. Patrick's for the Irish and St. Mary of the Assumption for the Germans.

On March 17, 1863, a contract was signed to build the first structure at St. Mary's: its school. Considering the date, it's a wonder our neighborhood church wasn't called St. Patrick's too.

The school served as a temporary house of worship until 1868, when the Gothic-style church was dedicated. In 1872, a rectory was built; in 1875, a convent was constructed; in 1894, the spire and clock were added to the church building; and in 1896, the school was expanded.

And so the scene was set for Monsignor Burkley. As he preferred to be called "Father," I'll do so here.

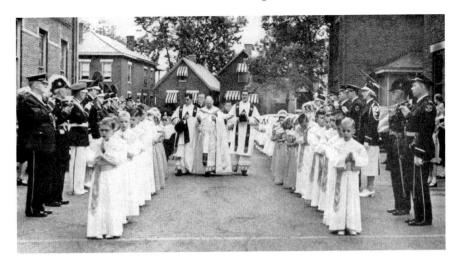

This 1955 St. Mary's golden anniversary program shows nos. 676–678, 682 and 684 Mohawk in the background and Father Burkley at center. The building to the left was the school and today houses a bank; the building standing to the right was the convent. The old convent stood at 685 Mohawk Street and later was expanded to include the two homes at 691 and 693. The early "sisters' dormitory" was a large brick building separated from St. Mary School (today the bank) by a yard. *Courtesy of St. Mary Church.*

St. Mary School campus. The building at the foreground was built in 1865 and is today's Specht Center; the rear building was built in 1887 and today is a bank. *Courtesy of the Columbus Metropolitan Library.*

Father Edmund Anthony Burkley was a presence both in and of the community, and he had a very personal stake in the prosperity of this neighborhood.

His parents, Mary Ann Brun and Edmund Burkley, were married at St. Mary's. Father Burkley was born on May 17, 1880, on Front Street and baptized at St. Mary on May 30 of that year. He was a direct descendant of one of the original committee members who founded St. Mary Parish.

Father Burkley attended St. Mary School for eight years, and as he lived on Front Street, he was very much a part of the South End and what would become German Village.

After receiving his education at the Josephium College on Main Street, Father Burkley was appointed assistant pastor of St. Mary's in 1906 and pastor in 1924. He was actively engaged in student life at St. Mary School, and he spent hour after hour recording student athletic and social events on his then state-of-the-art video camera.

And though Father Burkley was the leader of St. Mary's, he had great help in his endeavors. In 1875, the Sisters of St. Francis (Joliet, Illinois) came to St. Mary Parish and stayed for more than one hundred years. Certainly, in Father Burkley's time, these sisters guided decades of students through the halls of St. Mary's and, in turn, stirred the minds of generations of South End residents. To say the least, the children who attended St. Mary's had a strong foundation on which to grow.

Father Burkley attended sixty years' worth of talent shows, athletic events and other school events, and he was a large part of that history, befriending students and continuing to be a part of this neighborhood as he had been since birth. Graduates of St. Mary's remember his name day as being a special event for the entire school, and he was undoubtedly a figure to look up to and use as a role model.

Today, the preschool at St. Mary's is named in honor of Father Burkley, a man who clearly kept the future of St. Mary's and its students foremost in his mind as the pastor of St. Mary Church.

Father Burkley's legacy shows the importance of living a large life in the small world of German Village. His connection to St. Mary's was so great that an anecdote survives claiming that he lived on the same soil on which he was born. Ground was taken from his family residence on Front Street and placed underneath the present rectory. Small world indeed!

It is no wonder that small acts by one person can help shape a community. Just ask any graduate of St. Mary's.

A Look at Schiller from More than Two Hundred Years Away

The Friedrich Schiller Statue in its namesake park has been an institution in Columbus and the South Side since 1891. That year, the city's German community very deliberately chose to dedicate a bronze statue to honor Schiller, and one can't help but wonder exactly what merits an individual must achieve to have a 2,640-pound, twenty-five-foot-tall statue cast in his likeness more than three thousand miles from home.

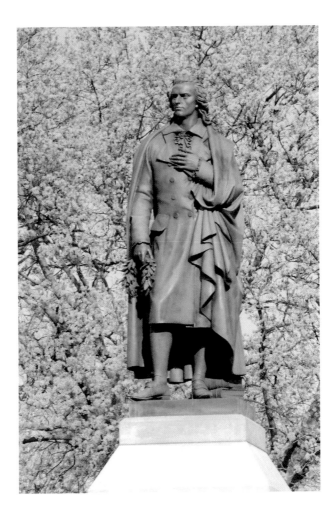

Schiller Statue, 2008.
Courtesy of Ed Elberfeld.

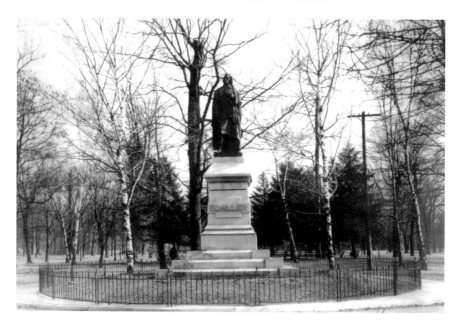

Schiller Statue. *Courtesy of the German Village Society Fischer Archives.*

To put it very simply, Schiller was a German poet, philosopher, historian and dramatist. He is often linked with Goethe, and the two are today considered key figures in German literature and classicism. But without question, it takes interesting beginnings to achieve such regard, reputation and, ultimately, ennoblement.

Johann Christoph Friedrich Schiller was born in 1759 in Marbach, Wurtemberg, located in southwest Germany. He went by Friedrich, but to his friends and family, he was "Fritz."

Schiller's parents hoped that he would become a pastor and therefore saw to it that he learned both Latin and Greek as a child. While studying at an elite military academy, Schiller wrote his first play, *Die Räuber* (*The Robbers*). Written in 1781, when Schiller was just twenty-two, *The Robbers* severely critiqued social corruption and affirmed the revolutionary republican ideals rampant among many of Schiller's countrymen. *The Robbers* made Schiller an overnight sensation.

While he wrote poetry, history and philosophy, today Schiller is considered among many Germans to be the country's highest-regarded classical

playwright. Select works include *Intrigue and Love*, a story reminiscent of Romeo and Juliet and ultimately the basis for Verdi's opera *Luisa Miller*; *Don Carlos*, a historical play loosely based on true figure Don Carlos of Spain; and *Maria Stuart*, a revisionist history of the Scottish queen and her rival, Elizabeth I.

For his achievements and literary contributions, Schiller was ennobled in 1802 by the Duke of Weimar. The honor resulted in his name changing to Johann Christoph Friedrich von Schiller.

Schiller lived in Europe during a time of great turmoil and change fostered mainly by the French Revolution and the Napoleonic Wars. Besides Goethe, Schiller's contemporaries included Beethoven and Mozart, and with these men, he participated in some of Germany's greatest cultural achievements.

A common theme throughout his works was the idea of people in crisis, and perhaps it is for this compassion that the German community in Columbus so revered him and donated his statue to what was then called City Park.

While we'll hopefully always recognize and appreciate Schiller's contributions, why do we care about this man who lived more than two hundred ago? We do so for one reason, really. Our predecessors in this neighborhood held this man in the highest esteem, and I think we owe it to their legacy to know why.

We learn about the architecture and social habits of the early German immigrants, but isn't it nice to also wonder about their political leanings and philosophical opinions? And isn't it interesting to think about how strong the German community in Columbus must have been to erect a statue of a German playwright in one of this American city's two parks? They were living in a completely different world from the one we live in today, and I think our history becomes richer when we think of the first villagers in their own historic context.

A descendant of Friedrich von Schiller visited the Meeting Haus recently. Imagine having the opportunity to maintain contact with a great-great-great- (and probably a few more) granddaughter of a figure so important to the history of this neighborhood? Or better yet, imagine knowing the impact that an ancestor of yours had on a community he never visited?

I hope that establishing a relationship with one of Schiller's descendants will give us a clearer glimpse of the man himself and what some of Columbus's leading early residents thought of him. And I hope, too, that his relative, who lives in Virginia, was able to appreciate more about Schiller after her visit to our much-loved Schiller Park.

OLD GERMAN VILLAGE BUSINESSES LEFT A LEGACY FOLLOWED TODAY

Since its very beginning, German Village has offered a healthy mix of residential and commercial properties. People have been patronizing local businesses in our neighborhood for more than a hundred years, and today the legacy of those mom-and-pop shops is thriving in the form of the German Village Business Community.

This young man stood near the intersection of Kossuth and Lazelle Streets, and the flat-roofed building behind him was the Brooks Bottling Company. *Courtesy of Jim Thomas.*

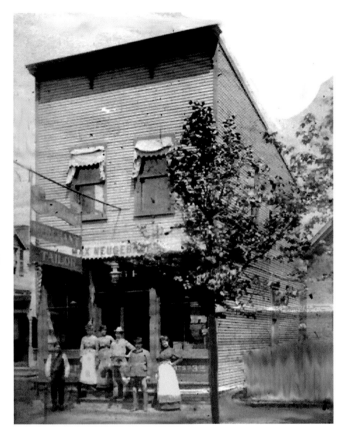

No. 764 Mohawk Street, Neugebauer's. This typical German Village commercial structure has housed the Columbus Battalion Band, the Clover Farm Store, the Mohawk Street Grocery, the Antiques Emporium and, from 1920 to 1921, Neugebauer Tailor Shop. *Courtesy of the German Village Society Fischer Archives.*

Early maps of the neighborhood show a variety of businesses; most focused on daily necessities rather than imported gifts, unique crafts, jewelry and art, but I suppose it would be unfair to fault them for that.

Bake houses, blacksmith shops, saloons, wallpaper shops, slaughterhouses, barbershops, wagon shops, tailors, grocers, stone cutters and upholsterers were scattered throughout German Village.

People didn't need to go far when they needed something, and in many ways, that is still true today. Not only has German Village maintained its architectural history, but we have also maintained the basic "footprint" of the neighborhood's residential and commercial mix.

One fascinating personal account from Mr. Jim Thomas tells about growing up at the corner of Kossuth and Lazelle in the 1930s and 1940s. He wrote, "The stores and businesses in German Village provided us with everything we needed."

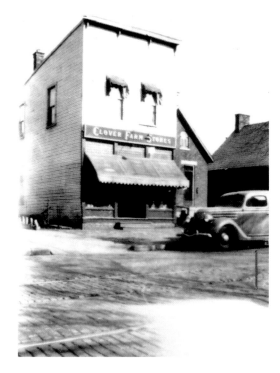

No. 764 Mohawk Street, Clover
Farm Stores. *Courtesy of the German
Village Society Fischer Archives.*

Stores included Spangler Cleaners at the northwest corner of Whittier
and Third, Maple Dell Ice Cream at the northeast corner of Whittier and
Third, Brook Bottling Company on Lazelle Street, Whipple Confectionary
at the northwest corner of Columbus and Mohawk, Alberts Pharmacy at
the southeast corner of Third and Sycamore and Schmitzer Barbershop on
Third Street between Frankfort and Kossuth.

Mr. Thomas wrote that "the Schmidt Packing Company was at the corner
of Kossuth and Jaeger Streets. Trucks carrying loads of animals would go
down Kossuth Street and occasionally an animal would escape from its pen."

Can you imagine what a sight it must have been to see adults and children
chasing after wild animals in the streets of German Village?

But think about how impressive it is that Schmidt's has been here for
so long. Generations of Schmidts have worked for the family business
and thrived right here in our neighborhood. While we joke that it
may get tiring telling the tourists how to get to Schmidt's, there's no
question that this establishment has added to the life and personality of
our neighborhood.

And so the newer businesses that made their homes in German Village do the same today. People shop here because they are looking for unique items, they eat here because they want different food and they stroll here because it's so easy to do just that.

And while you're shopping, think of all the businesses that have thrived in German Village over the years and how they paved the way for today's shops, restaurants and art studios. The businesses we support today are fulfilling a legacy started generations before them, and that mix of commercial and residential space is what makes German Village so unique.

PROST (CHEERS) TO ONE OF COLUMBUS'S PREMIERE BREW MASTERS

It takes a dedicated man to brew beer for more than fifty years, and while Columbus had several such men, August Wagner deserves particular attention simply because his family kept outstanding records.

When Wagner's daughter Helen died, she willed to the German Village Society an outstanding collection of beer steins, plaques, books, paintings and an archive's worth of newspaper clippings and photographs. And from all of this, one can piece together an image of this prominent man who lived for seventy-three years and died more than sixty ago.

August Wagner was born in Munich on August 4, 1871, and he immigrated to the United States soon thereafter. His first stop was Cincinnati, where he became a master brewer at the Christian Moerlein Brewery, one of the largest in the nation at that time.

Wagner eventually moved to Columbus, but from correspondence he kept, we can track where he spent his time between Cincinnati and the capital city. In September 1895, his superintendent at the Christian Moerlein Brewery wrote him a letter stating the following:

This is to certify that August Wagner has worked under my supervision for two years at the C. Moerlein Brewing Company, Cincinnati, Ohio. During this time Mr. Wagner has been employed in the different departments of said brewery and has proved himself to be a trustworthy and sober employee. I recommend him to my colleagues in want of anybody. Respectfully, Joseph Schneider.

Construction of Wagner Brewery. *Courtesy of German Village Society Fischer Archives, Helen Wagner Collection.*

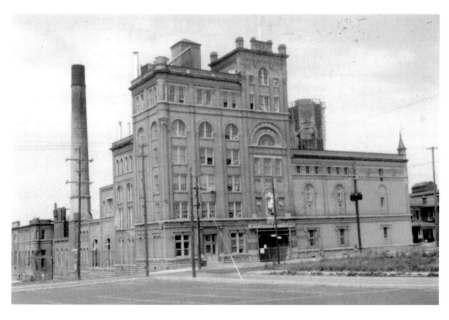

Wagner Brewery, 1967. Note King Gambrinus above the main entrance. *Courtesy of German Village Society Fischer Archives, Helen Wagner Collection.*

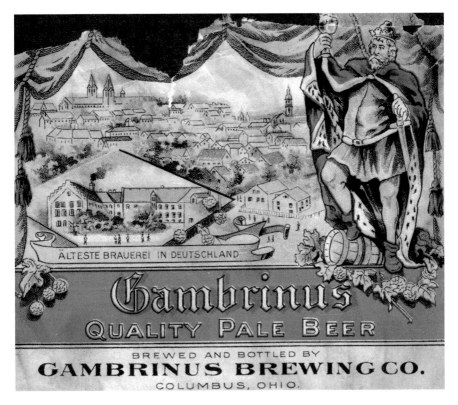

A "Gambrinus quality pale beer" label. *Courtesy of German Village Society Fischer Archives, Helen Wagner Collection.*

That recommendation served him well, and two years later, in June 1897, he received another favorable letter from his employer at the Scioto Brewery in Chillicothe. Proprietor Jacob Knecht wrote that Wagner had served as foreman for the past year and that he was not only competent in every respect but reliable as well.

Later in 1897, Wagner moved to Columbus and got a job working at the Hoster Brewery, an operation that began in the 1830s when Louis Hoster (for whom our Hoster Street is named) became one of the first German immigrants to open a brewery on South Front Street. Thanks to Wagner's prior experience in Cincinnati and Chillicothe, he quickly moved up the ladder at Hoster. But drama ensued.

Wagner's Malt Tonic, produced during Prohibition. *Courtesy of German Village Society Fischer Archives, Helen Wagner Collection.*

In 1905, the following was printed in a Columbus newspaper:

> *August Wagner, brew master of the L. Hoster Brewing Company, L.W. Prior local manager of the Hoster plant, and for 20 years financial man for the Hoster Co., and Charles C. Janes, advertising manager and assistant city agent for the Hoster Associated Brewing Company, tendered their resignation Wednesday to take effect at once.*
>
> *The resignations of Wagner, Prior and Janes, came as a surprise to the Hoster Associated people, who are in city, as did also the fact that the men who resigned were to be connected with a new brewery company, backed by certain Columbus interests with over $1,000,000 at their command.*

Ultimately, Wagner left to open the Gambrinus Brewing Company, which was located in the South Side at the northwest corner of Front and Sycamore. The other gentlemen who left Hoster with Wagner started a new brewery on the North Side of Columbus.

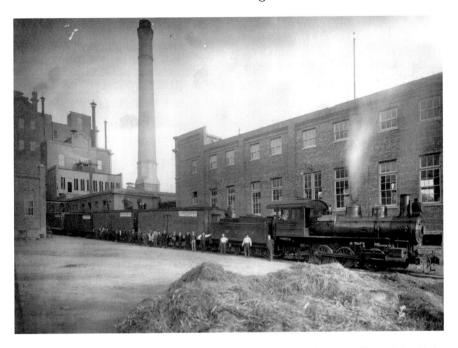

A train picking up barrels of Wagner beer for delivery. *Courtesy of German Village Society Fischer Archives, Helen Wagner Collection.*

Wagner's brewery stayed under his family's control until 1968, and in that time, it was called the Gambrinus Brewery, August Wagner & Sons Products Company (during Prohibition, when beer could not be produced), August Wagner & Sons Brewing Company and the August Wagner Breweries, Inc. (after his last remaining son died).

Wagner's brewery produced Gambrinus and Augustiner beers, and the labels on the former were graced by an image of King Gambrinus himself. The Gambrinus Statue, now standing on South Front Street near Kroger, originally stood above the door to Wagner's brewery.

And for all Wagner's mention of his sons, it would be his daughter Helen who would follow in her father's footsteps. When Wagner died in 1944, his brewery was left in trust and willed to his daughter, Helen, who served as vice-president until 1968.

In 1974, the brewery closed, and the building was razed. All that's left is the mighty King Gambrinus standing on South Front Street; five boxes of articles and photographs called the Helen Wagner Collection; many, many historic and

beautifully crafted beer steins collected by Wagner; several paintings; and books on the history of brewing beer. Actually, it's quite a lot when you think about it.

So what is the lesson to be learned here? There are two: be good at what you do and you might just have a family legacy on your hands, and keep your correspondence and photographs, because if Mr. Wagner hadn't, we wouldn't know much about him at all.

And clearly, he is worth knowing about.

HOMETOWN HERO CELEBRATED FOR A CENTURY

On October 8, 1890, Edward V. Rickenbacker was born. He is perhaps the most famous native son that the South End of Columbus, or perhaps all of Columbus, can claim.

Rickenbacker was a lauded World War I fighter pilot who was dubbed "America's Ace of Aces." In 1918, he was awarded the French Croix de Guerre for shooting down five German airplanes. His record of twenty-six aerial victories stood until World War II.

Rickenbacker took on Germany's legendary Red Baron and came out on top. As a testament to how complicated the times were for German Americans, Rickenbacker, whose parents were German-speaking Swiss immigrants, changed the spelling of his last name during World War I. He wrote in his autobiography that "from then on, most Rickenbachers were practically forced to spell their name in the way I had."

Based on my very limited study of Rickenbacker, I feel safe in saying that he was an adventurer. He was known as "Fast Eddie" in his neighborhood because he was touted as the first man to drive a mile a minute. He loved machinery of all sorts and raced in the 1912, 1914, 1915 and 1916 Indianapolis 500.

By the time the United States declared war on Germany in 1917, Rickenbacker had enlisted in the army and was training in France with the first group of American troops. He entered the ranks as sergeant first class.

Rickenbacker had ended his formal education at the age of twelve when his father died, and when he expressed interest in flying during the war, he had to compete against men who had formal college degrees. His engineering capabilities earned him a position as an engineering officer, and he practiced flying during his free time.

Once Rickenbacker found a qualified replacement for his engineering post, he was granted a position in the Ninety-fourth Aero Squadron, America's second air combat squadron. Rickenbacker proved to be a quick learner and skilled pilot, and throughout his tenure in the army, he and other pilots developed aviation principles that were instrumental in civil aviation up through World War II.

Along with his record of twenty-six victories, Rickenbacker flew a total of three hundred combat hours, reportedly more than any other U.S. pilot during the war.

Until Charles Lindbergh's historic flight over the Atlantic, Captain Eddie Rickenbacker was the most celebrated U.S. pilot ever.

Perhaps as much as he was known for his wartime victories, Rickenbacker was known for his many near-death experiences. That's right—a true adventurer has many, not just one.

His very first such experience happened when he was living at his family home on Livingston Avenue. He lived near a mine and was almost killed when he and some friends decided to play in it.

In 1941, Rickenbacker was in an airline crash that so damaged him, the ambulances that came to transport the bodies of those injured left him behind thinking he was dead. If that wasn't bad enough, by the time he arrived at the hospital, doctors instructed staff to "take care of the live ones" and ignored him.

Just one year later, after making a full recovery from the plane crash, Rickenbacker was adrift at sea while on a mission to deliver a secret message to General Douglas MacArthur during World War II.

He, his business partner and the crew of the ditched aircraft drifted at sea for twenty-four days. The army searched for them for two weeks, and finally the navy found the group near Samoa. But before he and the group were found, the press reported Rickenbacker dead (for the second time in his life). Incidentally, upon his rescue, Rickenbacker turned his message over to MacArthur.

Known for his patriotism and bravery, Rickenbacker was a hometown hero whose influence was felt around the world. In his own words, "Courage is doing what you're afraid to do. There can be no courage unless you're scared."

A TRADITION SEVENTY-SEVEN YEARS IN THE MAKING

Every building in German Village has a unique and interesting history. Sometimes, important older history gets overshadowed by more recent history, as has been the case with the building at 541 South Third Street.

Today, we think of it as Pistachia Vera, but more often than not, the building is still called "Thurn's" by locals. Believe it or not, the word "Reiner's," written in brick on the building, has some meaning too.

On May 15, 1912, Gottlieb "George" Reiner arrived in New York City after traveling aboard the *Kronprinz Wilhelm* from Bremen, Germany. On the ship's manifest, George, then age twenty-four, noted that he could both read and write. His occupation was baker.

George settled in Columbus, Ohio, and in 1930, he opened a bakery near his home in the city's South End. He named the business for his family, and the operation thrived until his health declined in 1974.

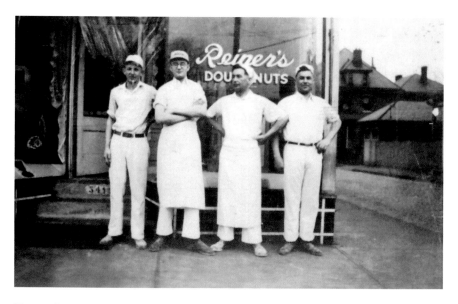

No. 541 South Third Street, Reiner's Bakery, 1930s. Gustav Reiner is at the far right, his brother Fritz stands next to him and the other two gentlemen are likely original employees of the bakery. Gustav and Fritz were nephews of Gottlieb "George" Reiner, who opened his bakery in 1930 after emigrating from Germany. Gustav later went on to establish the still-prospering Oakland Nursery. *Courtesy of Matt Reiner, son of Gustav Reiner.*

Along with George, his wife and their two children, Reiner's twenty-two-year-old nephew, Gustav, lived with the family when he arrived in America in 1928. While the 1930 census notes his uncle's occupation as proprietor of a bakery, Gustav's occupation was helper in the bakery.

For forty-four years, the Reiner family owned and operated their bakery at 541 South Third Street. The former dwelling was converted for bakery and restaurant use, and a large addition was added to the rear of the building for equipment. It is that Hoster Street–facing addition that still declares "Reiner's" in brick today.

Reiner's was best known for its doughnuts, and when the bakery closed in 1974, the neighborhood was disappointed to say the least.

On June 6, 1974, the *Village Voice* wrote the following:

> *The machines were stilled. The blinds were pulled and the door was locked tight. News of the shutdown traveled throughout the village and brought an end to a morning ritual for many folks in the area.*
>
> *When the alarm goes off, I somehow manage to roll out of bed and lean against a wall. Then I stumble into the bathroom and throw cold water on my face. The only thing that used to bring me out of this inevitable coma was to get the word that there would be donuts for breakfast. You can imagine the great shock I received the day Reiner's shop closed.*

In 1974, Will Plank purchased Reiner's and renamed it Thurn's in honor of his wife's family. The Plank family operated Thurn's bakery and coffeehouse from 1974 to 2003.

Thurn's was known for its doughnuts, cakes, lunch counter and popular deli menu. But perhaps even more so, it was known for its crowd of regulars. Dubbed "the high school cafeteria of German Village," patrons of Thurn's, like patrons of Reiner's before, returned day after day, year after year. In their times, both businesses were neighborhood institutions, but Thurn's seems to provide the most memories for locals today. I suppose that's because Reiner's closed more than thirty years ago, but it seems a shame that all people know of that segment of the building's history is what's written on an exterior wall.

The building at 541 South Third Street could be a microcosm of German Village life. A German immigrant comes to America with a trade and turns that skill into a forty-year career that supported his family and livelihood.

A second business resumes the traditions and commercial trade of the first, and that business thrives for more than thirty years. And today, after sitting vacant for several years, a third bakery has opened its doors.

Members of both the Reiner and Plank families still have many connections to German Village and Columbus, giving our community a strong and direct tie to its past.

Our neighborhood has long been known for its eclectic mix of residential and commercial properties, and my hope is that the long-standing tradition of having a bakery at the corner of Third and Hoster Streets will remain true for generations to come. Bearing in mind, of course, that any future business will have huge shoes to fill when considering the powerhouse legacies that Reiner's, Thurn's and now Pistachia Vera have created for German Village.

Frank Fetch: The Man Behind the Village

Frank Fetch is the father of the German Village Society and has a public park named for him; he also has a hosta named in his honor. Given that horticultural distinction, it seems appropriate that we are all formally acquainted with the plant's namesake. We know him as the father of German Village and as a leader in urban revitalization, and as long as the German Village exists, he will continue to play a pivotal part in its history.

Frank Fetch was born in Akron, was reared in Columbus and enlisted in the United States Navy in 1917, just before his high school graduation. He is described as taking the ends off his words and having a pronounced drawl.

Perhaps what matters most to us is that Frank Fetch was a city employee who appreciated historic architecture and knew how to work the system.

He and his wife often met for lunch at the Clarmont Restaurant on High Street, and afterward they walked through the then-declining neighborhood around it. It was the late 1950s, and the Fetches, though completely unaware, were on their way to making local history.

You might say we've always attracted suburbanites. Frank and Elnora Fetch lived in Gahanna and bought a cottage on Wall Street to use as a rental property. While the rental trend is still with us, you'll note that Wall Street is outside of today's German Village boundaries. I think we owe a thank-you to the Brewery District for watching over that important cottage for us.

German Villagers

German Village Society founder Frank Fetch. *Courtesy of the German Village Society Fischer Archives.*

Lot on Beck Street in late 1950s that would later become Frank Fetch's namesake park. *Photo courtesy of the German Village Society Fischer Archives.*

Word quickly spread about the Fetches' restoration work. Given that downtown living and historic preservation had not quite come into their own by that time, the Fetches were commended for their "unique and noteworthy effort" to restore an old building.

Prevailing thought at that time supported urban renewal—the practice of razing older inner city housing and creating empty lots either for parking or to make way for the Interstate 70/71 interchange. Considering the time, Frank and Elnora Fetch were urban pioneers paving the way toward historic preservation.

Deciding to capitalize on the "buzz" created by their Wall Street restoration, the Fetches hosted a party to encourage like-minded individuals to help save the declining neighborhood just south of downtown.

Soon afterward, in January 1960, Frank Fetch hosted his now-famous open meeting at Schiller Park. More than two hundred people attended, and the German Village Society was born for the "preservation and restoration of the property in the area and the retention of its charm and old world atmosphere."

Believing that the loss of the old German neighborhood would diminish the city's cultural heritage, Fetch launched a major restoration and revitalization effort that still continues today.

By 1963, Fetch had used his city contacts and urged city council to appoint a German Village Commission with strong enough teeth to protect and regulate the area's architectural integrity. In April of that same year, the City of Columbus declared the 223-acre area the city's first historic district.

Newspaper accounts from the 1970s describe Fetch as stubborn and argumentative, but without question he argued for what he believed in, and we are the beneficiaries of that hard work. His determination helped establish both the German Village Society and Commission, his city contacts helped him work from the inside and his inventiveness raised property values in an area formerly considered a slum.

Thank goodness he was stubborn and argumentative for our side.

Like the hosta that now bears his name, Frank Fetch could be described as hardy, dependable and having the ability to come back each year with renewed enthusiasm. It is only appropriate that this new plant be displayed in another of Fetch's namesakes, Frank Fetch Park.

On Frank and Elnora's early strolls through German Village, they often wondered why they were the only ones out and about on the streets. While

imagining that today might seem difficult, I think the Fetches would be pleased to see how pedestrian-oriented we have become. Our narrow brick streets and sidewalks were made for walking, and thanks to Frank Fetch, they will be walked for years to come.

Neighborhood Leader Paved the Path toward Society's Fiftieth Anniversary

The roots of German Village as we know it today go deep, and as much credit as Frank Fetch deserves (infinite), we've never been a one-man show. Mr. Fetch was a motivating leader to a small group of visionaries who devoted both time and dollars to this neighborhood and made it what it is today. I wonder what they think about us turning fifty this year (2010).

Frank Fetch has the park as his namesake (and incidentally, the only excuse for not knowing Frank Fetch is being new to the neighborhood; visit the Meeting Haus to learn more), but one of the most-used spaces in the Meeting Haus bears the name of another leader. The Scheurer Room is named for William A. Scheurer, friend and contemporary of Mr. Fetch and neighborhood leader in his own right.

Mr. Scheurer never lived in German Village but was one of our loudest cheerleaders. He owned nine properties in the neighborhood, one of which was the building that houses Lindey's today. He noted in an interview that he purchased it out of self-defense. In 1964, long before Lindey's moved in, the building hosted what one may call an unsavory clientele (ask Pat Phillips about the gunfights), and Mr. Scheurer, who had heard complaints about the condition of the building, decided that the best way to get it cleaned up was to do it himself.

While I digress in my mention of Lindey's, I don't in Mr. Scheurer's basic principles. In a 1989 interview, Mr. Scheurer said, "If you get involved, you get compensated in one form or another. There are a thousand things to be done. Just look around. But you have to innovate and be aggressive."

That's the kind of spirit that was needed to revitalize this neighborhood, and with Mr. Scheurer's support, the "get in there and do it yourself" mentality took hold and gave German Village its teeth.

Bill Scheurer. *Courtesy of the German Village Society Fischer Archives.*

Mr. Scheurer served his adopted community well. He had a seat on the very first German Village Commission and served as a Society board member and ultimately board president. (Today, our board meets in the room named for him.) In our fifty-year history, Mr. Scheurer has been the only emeritus trustee. He was also a lifetime honorary member of the Maennerchor, a member of the Germania Singing and Sport Society and a Red Cross volunteer for more than forty years.

Former Society board president and current board member and Meeting Haus volunteer Jerry Glick remembers that Mr. Scheurer used to visit the old Meeting Haus at 624 South Third Street every day, and in his eighties, while regularly walking with a cane, he offered to help Jerry move. Talk about having a mindset to get things done by helping others!

Like Frank Fetch, Bill Scheurer was born in 1899; he served in World War I. What's most interesting to me is that I know the history of the neighborhood and the German immigrants who settled it, but I'm still guilty of occasionally thinking that these people lived in a vacuum of the 1860s. Although he didn't live in our neighborhood, Mr. Scheurer lived our neighborhood's history. He was born in the Black Forest in Ottenhafen, Germany, and spoke only German until he was ten years old. As an adult, he served as president of the Exact Weight Scale Company. His appreciation for German Village came from frequent lunches at the Olde Mohawk; his love for turtle soup steered him here, and his love for the neighborhood's history and potential for the future kept him here. In 1960, Mr. Scheurer and his wife, Jane, attended the first meeting of the Society, held in Schiller Park and called by Frank Fetch. From then on, he was hooked.

In an introduction to Richard Campen's 1978 *German Village Portrait*, Mr. Scheurer had the following to say about German Village:

> *More and more people are now beginning to appreciate the economy of space that characterizes German Village. The small, neat houses and yards lend themselves to busy modern lifestyles, while the proximity of the homes to the streets and to each other encourages a neighborliness often lost in suburban sprawl. The little shops still cater to a walking community. The quiet, narrow streets with their weathered brick*

buildings, trees and window boxes are a welcome refuge from downtown Columbus, so near and yet so far away.

I take comfort in the fact that his words are still true thirty years after he wrote them and hope you do, too.

IT TAKES MORE THAN BUILDINGS TO MAKE A NEIGHBORHOOD

When asking for topics for this column, a German Village Society board member suggested that I consider the people of our neighborhood rather than just our buildings. Since the two go hand in hand, it seems time to recognize some of the early movers and shakers of our Society and community.

German Village Society pioneers Grace Highfield and Dorothy Fischer. Cleaning and maintaining public spaces like the parks and sidewalks was an early step the Society took toward neighborhood beautification. Today, the Grace Highfield Garden in Schiller Park provides quiet and solitude near the Umbrella Girl Statue. *Courtesy of the German Village Society Fischer Collection.*

Considering that he founded the Society and was one of the first individuals to restore a house on Columbus's sound side, Frank Fetch deserves the recognition we so often give him. But while Mr. Fetch was at the helm when the Society was established in 1960, he also had a strong crew working with him.

As one of the original trustees of the German Village Society, Mr. Philip Kientz not only helped set early renovation guidelines for village homes but also lent his professional stone-masonry skills to many of the porches and stoops we see today. Additionally, for more than a decade, his wife, Shirley, served as secretary to the German Village Society.

In 2006, I had the pleasure of chatting with Mr. Kientz, and he told me that in the early 1960s, he and Mr. Fetch saved slate mantles from homes being demolished and stored them for people renovating their homes. The mantles were given to residents free of charge and no doubt made interior renovations easier for many neighbors.

Mr. Kientz also recalled the days when trustees helped older and homebound residents spruce up their properties by offering a coat of paint or some peonies for window boxes.

When he was named a trustee, he and Shirley lived at 820 South Fifth Street, the home they would live in for the rest of their lives. As longtime residents, both Kientzes became neighborhood institutions in their own right.

And here's a little known fact about this well-known pair: they were both engaged and married halfway through a ten-day leave Mr. Kientz had from the U.S. Coast Guard in 1942. It just goes to show that sometimes minimal planning works best!

Another charter member of the German Village Society was our first treasurer, Mrs. Dorothy Fischer.

On my first day in August 2005, Mrs. Fischer made a point to visit me at the Meeting Haus, welcome me to the Society and give me photographs that she came across in her scrapbooks. No small feat for a woman then in her nineties!

By now, I have come to recognize Mrs. Fischer's distinct handwriting on the backs of photographs. Her notes have proven 100 percent accurate and have helped me organize many loose photos.

Her husband, Ralph Fischer, helped document the changing village by photographing homes and streetscapes over several years. His collection of

A Village Valuables promotional shot of Susan Cox and Peggy Threadgill. Since the very first Village Valuables, this event has drawn thousands of visitors to German Village for a neighborhood-wide yard sale, always held on the third Saturday of May. *Courtesy of Fred Holdridge.*

photos numbers in the hundreds, and it provides an indispensable key to knowing the Society's humble beginnings.

Mr. Fischer also took pictures at early Haus und Garten Tours, and in the forefront of many of those photos is his wife, Dorothy, leading tour groups

throughout the village. Even forty years ago, visitors seemed to tower over her tiny frame, but her hard work on early tours helped create a legacy.

The hard work of early German Village Society activists, trustees, commissioners, members and staff has gotten us to where we are today. Unfortunately, many of those early players are no longer with us, but from those who are, we have much to learn.

The charter members of the German Village Society were a tenacious bunch with a long-range vision. Bill Lenkey and Cloene Samuels are still active members in the Society today. Other longtime residents like Ann Lilly, Pat Gramelt, Madeline Hicks, Fred Holdridge and the Puseckers helped shape the early memories of the German Village Society and our neighborhood. I think we all know the immigration history of our neighborhood, but we should take every opportunity possible to learn of our more recent past, and these are the people to ask.

And while we're at it, we should thank them for the many hours they have devoted to our neighborhood. They are the ultimate caretakers of our legacy!

A Look at Newspapers Past

Ben Hayes was a journalist for the *Columbus Citizen Journal* in the 1950s and '60s and was hugely instrumental in the success of German Village. He wrote regular columns that featured the restoration work in the South End and was a true blue friend of the neighborhood for his enduring support.

Rooting through the file cabinets at the Meeting Haus, I came across *The Ben Hayes Scrapbook*, which includes anecdotes and columns that both Hayes and his biggest supporters chose to include for posterity. Several make mention of our neighborhood's roots in beer brewing, such as the following:

"A Foamy Beer Story"

A man I encountered on a bus told me a story he once overheard on a street car. And before that a driver of a horse car probably told it. For endurance, it may win a prize.

A stranger entered a South Side Saloon and told its proprietor, a German, that he was selling Shakespeare. The German shook his head. "We have

Born's beer and Hoster's beer and Schlee's beer," he said. "But we never heard of Shakespeare."

"No—no," said the stranger. "It's books—I am selling books."

The German shook his head. "Then come back next spring," said the saloon man. "Then we have books beer."

Anyway, it's a reminder that bock beer time is here. And Fred Reiner, the German Village baker, recommends with it ham and pumpernickel.
[March 2, 1962]

Born, Hoster and Schlee were all German brewers who owned breweries in today's Brewery District, and Reiner's Bakery was an institution at 541 South Third Street for decades.

Another column entitled "Hoster" reveals more about the aforementioned South End brewery:

The big name in Columbus brewing was Hoster. The brewery's red brick buildings with lofty hipped roof, turrets, and octagonal base of its once-tall smokestack loom large beside the South Innerbelt.

The Hoster buildings, no longer used for brewing, still dominate the South Front Street brewery district. Now that the Fulton and High corner will be cleared, the brewery will be more conspicuous than before.

Michael Dickerson and I expressed curiosity about the interiors, so Al Wasserstrom graciously took us on a tour, the major part of which was subterranean.

Big tunnels run between the buildings. One is beneath Front Street, because the beer was bottled on the east side of the street. The ice house was across Ludlow Street to the west. The handsome horse barn, also brick, still stands south of the brewery.

Cellars look European and are now painted white. Arched over them are wide barrel vaults, and rising above the cellars are brick walls nearly four feet thick. Both limestone and sandstone were used for foundation and trim.

Even in this era of "complexes" the Hoster buildings stand as a major construction feat. Hoster once boasted (in 1896) that its endeavor was a "million dollar turnover" each year; 12 months of its production was 175,000 barrels of beer.

To turn out 175,000 barrels of beer, as in 1896, Hoster's required each year a million bottles, 25,000 bases, and 50,000 barrels and kegs. The ingredients were 250,000 bushels of malt, and 150,000 pounds of hops. Other figures from the 1896 report: 150 men, 11 horses, 50 wagons.

This quick look through Ben Hayes's columns actually reveals quite a bit about the city's history and what Columbus was like when the columns were written. As a friend to German Village, Ben Hayes supported our neighborhood's endeavors toward restoration and downtown living. He has a looming presence in our file cabinets and archives, and his name is in our books as an early German Villager indeed.

STRUCTURES, STREETS AND PARKS

Carved from Neighborhood but Still Very Much a Part of German Village History

Before Interstate 70 sliced through the neighborhood, Trinity Lutheran Church had a much greater presence in German Village.

The original forty-four-member German Evangelical Lutheran Trinity congregation began holding regular services in January 1847, led by the Reverend C. Spielman. Because funds were not immediately available to build a new church, the budding congregation met in a seminary building at South High and Sycamore Streets.

Trinity served some of the earliest German immigrants arriving in Columbus, and since there seemed to be a greater need for Lutheran churches than Catholic at the time, it makes me think that more German Lutherans were in that first wave of immigrants and more German Catholics followed later. (St. Mary's didn't open its doors until 1865, twenty years after Trinity.)

The new Lutheran congregation initially rented space from the Independent Protestant Church on Mound Street for $120 a year. As the congregation grew, the rent increased, and after eight years, the future members of Trinity Lutheran Church were paying $200 each year to rent the space. This was a significant amount in the 1840s.

In 1854, there were 250 communicants, and the decision was made to begin looking for property. The church considered purchasing Second

Trinity Lutheran Church, 1960s, after demolition and construction had begun on Interstate 70. *Courtesy of the German Village Society Fischer Archives.*

Presbyterian Church at Third and Main for $10,000 but quickly decided the building wouldn't best suit the needs of its growing community.

In April 1856, the lot on the northeast corner of Third and Fulton was purchased for $2,300. That June, the congregation voted to erect a two-story church measuring 56 by 120 feet. The cornerstone of the new church was laid in July of that year—just eight years after the church was organized.

Given the fact that this congregation was in large part composed of immigrants new to this country, likely with very little means, I think building a church less than a decade after the congregation was organized is incredibly impressive. The estimated cost of the building was just over $12,000. The spire was added in 1876 at a cost of $3,470.

As the congregation of Trinity Lutheran Church grew and aged, it became more and more difficult to hold services in German, as young children were becoming more and more Americanized. By 1924, all services at Trinity were spoken in English, with the exception of two German services held twice each month.

And while the church itself is a beautiful building, it's the windows that are particularly noteworthy.

Under the leadership of Reverend C.C. Hein from 1902 to 1924, the church underwent numerous improvements, including the addition of stained-glass windows donated by individuals as memorials. These incredible windows were designed and crafted by the Von Gerichten brothers, who owned the Columbus-based Von Gerichten Art Glass Company.

Von Gerichten produced windows of both domestic and international acclaim, and several award-winning windows still exist in Columbus today.

In 1904, the company received the grand prize and four gold medals at the Louisiana Purchase Exposition held in St. Louis. Unfortunately it is unclear which of their windows won the prizes.

What is for certain is that the award-winning windows were not those that were installed at Trinity Lutheran Church. This is clear because Ludwig Von Gerichten asked the church's board of trustees for permission to delay the installation of the windows in order to include them in the competition. The trustees, impatient after waiting forty-seven years to replace their "temporary" plain windows, didn't want to wait any longer and voted to install the new stained-glass windows immediately.

Understandable, I suppose.

The church has prospered and thrived for many generations, and with the construction of Interstate 70 in the 1960s, its ties to its German community seemed strained, to say the least.

Today, rather than being surrounded by a neighborhood like St. Mary's, Trinity sits at a busy intersection alongside entrance ramps to the Interstate. But its congregation proves strong today, and while its history has secured it an important chapter in the history of the South End, this church's future will no doubt continue to do the same.

THURMAN AVENUE PROPERTY HIGHLIGHTS ADAPTIVE REUSE BEST PRACTICES

Until I'm blue (or green) in the face, I'll harp on and on about how historic preservation is as green as it gets. Rehabbing an old building makes more efficient use of energy than demolishing a structure and rebuilding another. Repairing old windows and giving them a tighter fit makes more sense than throwing them in a landfill and installing new units, and letting natural light into large windows and transoms makes more sense than shuttering them and flipping a light switch.

Perhaps the greatest example of recycling in architecture comes in the form of adaptive reuse. This method is little more than using a building for a purpose other than that for which it was built. Case in point: the Big Red Rooster, or as many of us still think of it, Engine House No. 5.

Engine House No. 5, undated. *Courtesy of the German Village Society Fischer Archives.*

Built in 1894 to serve as the South End's engine house, the building now provides office space for an acclaimed marketing firm. The engine house stands at 121 Thurman Avenue, at the corner of Thurman and Fourth, formerly Mozart Avenue. Its location was chosen because in the late 1800s, engine houses were placed ten blocks apart (remember that residents were relying on true horse power to get water to fires).

The engine house could hold eight men, four horses, a steam engine and a wagon; it cost $15,000 to build. Granted, $15,000 in 1894 is different than $15,000 in 2009, but it was not a bad investment on the city's part for a building that's been standing for 115 years.

The station officially closed in 1968, and it wasn't until the mid-1970s that the building was reopened as the seafood restaurant so many villagers remember fondly. The decade of the 1970s was pivotal in the historic preservation movement, not because of specific legislation passed, but more because of the momentum that had built and the fact that "historic preservation" was a term people were beginning to understand.

Historic preservation got its chops in the 1960s, and naturally it took time for the movement to gain strength at all government levels. But by the 1970s, German Village had truly become a hotbed of preservation, restoration and rehabilitation activity, and those three basic tenants left only one to take root: adaptive reuse.

There is no rule or iota of common sense that dictates that a building must be used for the purpose for which it was built. If that was the case, 121 Thurman and the Third Street School would both stand vacant today, the Meeting Haus would be a Moose Lodge and a delightful artist studio on Columbus Street would be a mechanic's garage.

These buildings took tremendous energy, effort and expense to build, and sure, they take some of the same to maintain, but not nearly the percentage that would be necessary to demolish and rebuild.

Plus, the fact that the old engine house at Thurman and Fourth still stands tells an important piece of our neighborhood and this city's history. This wasn't always a tourist destination or neighborhood renowned for its preservation ethic. But it has always been a place where people lived, worked and cared for their investments.

While the placement of engine houses may seem little more than a footnote in the city's history, it is important in its own right. This engine house served our predecessors in the most practical sense there is, and while perhaps no use of the building could compete with the practicality of a fire engine house, the business that operates out of 121 Thurman Avenue today adds to the vibrancy of German Village and contributes to our healthy residence-to-business ratio.

Today, adaptive reuse seems (thankfully) commonplace, but the developers of Engine House No. 5 had tremendous foresight in the 1970s when they opened their restaurant. And besides, not only does reusing a building lend to our planet's sustainability, but also, I dare anyone to find the charm and character in one foot of a new building that a 155-year-old building has in its smallest square inch.

ABSTRACTS OF TITLE REVEAL NOTEWORTHY PAST FOR MANY PROPERTIES

Property abstracts are fascinating documents. They may look intimidating with their heavy pages and curlicue script, but the information they yield is incredible. When coupled with other documents, unlocking the mysteries to a property's past are a lot easier than many expect.

Let's use the house of a longtime German Village resident and friend as an example. As I'm sure readers know from my harping, President Thomas Jefferson granted some of the land that is today German Village to a Canadian fellow named John McGowan, who served on behalf of our country in the Revolutionary War. His thank-you for such service was 328 acres and 51 perches of land.

Photo of Nelson Richard Palmer, age four months, three weeks, taken in December 1925 at the photography studio at 202 East Beck Street. *Courtesy of P. Susan Sharrock.*

In 1813, McGowan and his wife, Sarah, sold a portion of their property to Samuel Parsons, for whom Parsons Avenue is today named. Parsons had many tracts of land in the area, but this particular piece was ten acres purchased for $200.

What follows is a perfect example of why people get confused by abstracts. The description of Parsons's purchase states:

> *Beginning on the northern boundary line of said half section at the distance of seventy six rods, east of the intersection of the east side of High Street in the Town of Columbus, with the said boundary line, thence east on said boundary line forty rods thence south forty rods, to a stake on the bank of a small branch of a creek, thence west forty rods to a stake thence north forty rods to the place of beginning, the same lying and being in the county and stake aforesaid together with all improvements, water courses, profits and appurtenances whatsoever, to the said premises belonging or in any wise appertaining.*

It's helpful to note here that a rod equals 16.5 feet.

Parsons owned this and other land until his death in 1858, and I know this because Parsons's will is included in this property abstract. Parsons named his son, George, as the executor of his estate and divided his property between George and his sister, Elizabeth Jane Scott. During his lifetime, Samuel Parsons loaned George a little more than $11,000, and he made it a point in death to even things up: everything was split evenly, but Elizabeth got $11,000 extra.

Another interesting note included at the end of the will says that Parsons bequeathed his medical library to his nephew, James Banks, MD, of Chicago, Illinois. So anyone wishing to research Parsons more would know that he likely practiced medicine and also had family in Chicago.

In 1858, George Parsons and his wife, Jane, appointed their attorney, James Bates, to sell all of the land Samuel Parsons had left in Fulton, Henry, Defiance and Williams Counties, plus all of the lots in Parsons Addition in the city of Columbus. The Parsons's involved their attorney because at the time they were living in Paris, France, and apparently deemed the sale of the property too difficult from abroad. Understandable, I suppose.

So now, anyone wishing to do research on the Parsons family has a link to France. See how all of these little pieces come together, and from just one document so far?

In May 1868, Bates worked on behalf of George and Jane Parsons and William and Elizabeth Scott to sell lot no. 63 of Parsons Addition in Columbus to Mr. Franz Joseph Wiss and his wife, Cecelia, for a sum of $400.

Twenty years later, Wiss sold the property to Ottillie Mayer for $1,600. And while property values can certainly increase over two decades, it is likely that it was during Wiss's tenure as property owner that at least one structure was built on the property, thus increasing the land's value. The land is described as follows: seventy-seven feet in length by the width of the lot, off of the south end of lot no. 63 of Parsons Addition.

Essentially, lot no. 63 was cut in half, and Wiss sold the bottom half to Ms. Mayer and her husband, Alfongs. The north, or top, half of the lot eventually housed the structures at 203 and 205 Berger Alley. The south, or bottom, half had 202 East Beck, plus another two-story structure that was first used as a house and then, according to the 1901 and 1922 Sanborn maps, as a photo studio.

According to the 1923 Columbus city directory, the Mayers still owned the property at 202 East Beck Street, but a Mr. Adolph Baer used the two-story outbuilding as a photography studio. Sometimes this outbuilding is labeled 202½ and sometimes it is shown as 202 East Beck Rear.

Ultimately, the lot was split, and today the house facing Beck Street is 206 East Beck, while the former photography studio is 202 East Beck. It's an imposter address, though, since the building actually fronts Macon Alley.

And that, my friends, is the kind of information that can be gained from reading an abstract of title. That document shared with me a wealth of information and provided the starting point for my research using Sanborn maps and city directories. All because my friend P. Susan Sharrock asked me to take a look at her abstract—and what fun I had!

WE'RE ALREADY APPROACHING "THAT TIME OF YEAR"

Parents love it and kids seem to hate it. I'm talking about going back to school, of course.

For a neighborhood of German Village's size, having both Stewart Avenue School and St. Mary's is impressive, but don't forget that we once had a third: Third Street School.

Third Street School plan drawings. *Courtesy of the Columbus Metropolitan Library.*

Although today it serves as the Golden Hobby Shop, the Third Street School was at one time the oldest operating public school in Columbus. Construction began in 1864, the building was dedicated in 1866 and it functioned as a school until 1975.

An 1891 map labels the building simply as "Public School No. 6," and in 1951, the building was labeled the "Third Street Public School for Crippled Children." In the midst of those sixty years, sometime in the 1920s, the entrance to the school was given a face-lift.

What was formerly a very simple double wooden door with an arched window above it became the impressive door we see today. Inscribed above the door is a quote from Socrates, reading, "Learning Adorns Riches and Softens Poverty." As the nation moved into the Great Depression, these were likely very comforting words.

By 1975, the building was being used as a school for girls, and thoughts turned toward making it a museum once it closed at the end of that school year. Instead, the Columbus Board of Education sold the building to the City of Columbus, which in turn converted the building to what it is today: an arts and crafts center for artists and craftsmen aged fifty or older.

The Golden Hobby Shop sells a variety of useful and decorative gift and home items, and its inventory includes hand-made furniture, quilts, paintings, jewelry, clothing and baby and children's items.

What really is wonderful about the building is that, while it is no longer used as a school, it is still open to the public and serves its community well.

Many generations of German Villagers walked through the doors of the Third Street School, just as many walked the halls of St. Mary School when it was on Mohawk Street (today U.S. Bank) and attended Stewart Avenue Elementary. With Barrett and South High also close by, I can't imagine any student having a long walk to school throughout our neighborhood's history.

Frank Guza and fellow students in the schoolyard behind the Third Street School in 1920. *Courtesy of Guza's daughter and lifetime German Village resident Pat Gramelt.*

Education was of huge importance to the German community who settled the South End, but it is our luck today that their beautiful and obviously well-constructed schools remain as a testament to that importance.

So next time you're out walking, take a second look at the Golden Hobby Shop. Look for the large inscribed stone that proudly reads "Public School No. 6" and for the Socrates quote at the front door. And by all means, stop in to see the wonderful crafts that are for sale inside. In order to make the best use of old buildings such as this one, it's crucial to have people walking both inside and out to explore all it has to offer.

137 Years Hard at Work: Stewart Avenue School

Whether you know it as Stewart Traditional Alternative Elementary, Stewart Avenue School, Schiller School, New Street School or City Park Avenue

Stewart Avenue School second grade class, 1895. This structure has been continuously used as a school since it opened in 1873 and today serves as the adopted school of the German Village Society. *Courtesy of the German Village Society Fischer Collection.*

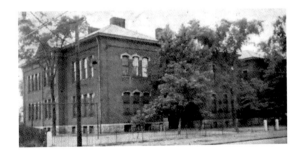

Stewart Avenue School, 1920. *Courtesy of the Columbus Metropolitan Library.*

School, the historic school facing Schiller Park has been a German Village treasure since 1873.

Here is a quick history of all those names. Until 1892, City Park Avenue was called New Street, which, if you look closely, explains the name above the entrance to the school. When the street name changed in 1892, so did

the school's name, although only for one year. In 1893, the school board changed the name to Schiller School in honor of German poet Friedrich Schiller. This, incidentally, was two years after the Schiller Statue in what was then City Park was dedicated. Finally, in 1894, the school was renamed Stewart Avenue School. Fortunately, the name stuck—for a while anyway.

The most recent name change at Stewart reflects its transition to a traditional alternative elementary school in response to the declining school-age population in German Village.

When the school was built in 1873, both German and English classes were offered in each of its eight grades. According to *A History of German Village to Approximately 1900*, Stewart Avenue School cost $24,500 to build and could seat 490 students.

Likely due to a growing population in the neighborhood, an addition was added to the building around 1925.

Like many homes in the village of that period, Stewart Avenue School is Italianate in design, and the building exhibits many of the visual elements common to that design. Take a walk down to the school and see if any of these features jump out at you: tall windows with hoods or

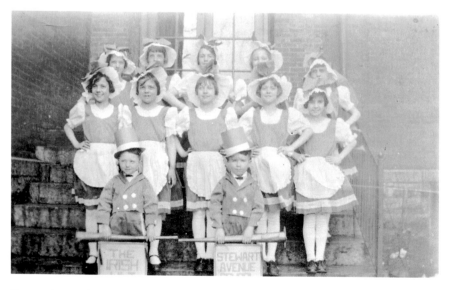

Stewart Avenue School students, undated. Note that the banner references an Irish affiliation. *Courtesy of the German Village Society Fischer Archives.*

"eyebrows," a projecting cornice at the roofline or an entry portico. These elements all work together to create a building that looks impressive and permanent—always important factors for institutional architecture.

As a neighborhood, we should consider ourselves lucky that the building at 40 Stewart Avenue is still being used for its original purpose. Consider the linear architecture of modern elementary schools versus the gem we have in Stewart, and think of the added learning experience the students at Stewart get just by looking at their building and its surroundings. Plus, we keep the added benefit of having children in the neighborhood.

And to ensure that Stewart students appreciate their building's history and gain a sense of its vibrant past, there is a display case in the hallway to showcase mementos.

As the adoptive school of the German Village Society, Stewart offers volunteer opportunities for individuals interested in tutoring, and our relationship continues to strengthen with each academic year.

The newest addition to the grounds at Stewart is the updated playground equipment. In 2006, the German Village Commission approved plans to install the new equipment on the north side of the school, and having walked by the school during recess, I know the playground is well used and much loved. Funds for the playground were raised by the PTA, whose members sold commemorative bricks to raise those last few dollars and cents.

Stewart is as much a part of our neighborhood as any of our homes, parks or brick streets, and it is so valuable for us to have the school and its students play an active role in our community. Without question, the fabric of our neighborhood is richer for having Stewart Traditional Alternative Elementary within our boundaries.

Take Advantage of the Best-Looking Twenty-three Acres in Columbus

Spring is the time of year when we can take full advantage of our picturesque and historic surroundings. One site in particular gets lots of use in the spring months and therefore deserves a little extra attention.

"Entrance to Schiller Park," postcard. Note how heavily wooded the park appeared. *Courtesy of the German Village Society Fischer Archives.*

For those of us who use Schiller Park for dog walking, planting, exercising, acting and strolling, here is some historical information that might be of interest next time you're in our fair commons.

In the early 1800s, John Binden sold a portion of his land in the newly established and heavily wooded city of Columbus to a gentleman named John Stewart. This land soon became known as Stewart's Grove.

In 1830, Stewart's Grove hosted the first documented Fourth of July celebration in Columbus. At this point, the South End would still have been quite young, so this was probably not on par with today's Red, White and Boom!

Fifteen years later, in 1845, the city's German population was steadily increasing, and Stewart's Grove was the site for Captain Otto Zirkle's German regiment's swearing-in ceremony before it left to serve in the Mexican-American War.

In 1848, Captain Zirkle's men returned to the park to celebrate their victory and safe return.

Schiller Park Gazebo, 1901. *Courtesy of the German Village Society Fischer Archives.*

In June 1852, as a testament to the strength of Columbus's German population, Stewart's Grove hosted German singing societies from places like New York and St. Louis during a national convention.

The Ohio State Fair was held at the site in both 1864 and 1865; it was an early precursor to 1960s Oktoberfest celebrations in the park.

In 1866, Francis Stewart sold his land to men with two familiar-sounding surnames today: David and William Deshler and Allen Thurman. The men agreed that a portion of the land known as Stewart's Grove would be designated as a park for community use.

One year later, the City of Columbus purchased twenty-three acres of Stewart's Grove from the Deshlers and Thurman for $15,000 and named it City Park. Some of the improvements the city made included adding a pond with an Umbrella Girl Statue in the center, a small zoo, a boathouse and a spring-fed horse pond.

The year 1871 proved to be an extremely exciting one for City Park. The large German population of Columbus celebrated the unification of Germany by planting an oak tree in the park. Here again we meet our old

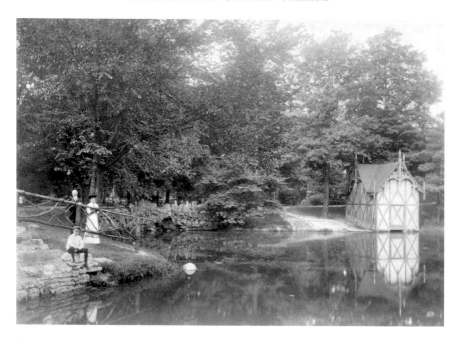

Schiller Park Boathouse, early 1900s. *Courtesy of the German Village Society Fischer Archives.*

friend Otto Zirkle, only now he goes by "Doctor" rather than "Captain." Dr. Zirkle was the master of ceremonies for the planting, and in attendance that day was German prince Alexander von Lynar, who was visiting Columbus to marry Miss May Parsons.

On July 4, 1891, a statue of Johann Christoph Friedrich von Schiller (he went by Friedrich) was placed in the park by the still-prominent German community. Schiller was a German poet, philosopher, historian and dramatist, and he lived from 1759 to 1805. He was born in southwestern Germany, the same region from which many Columbus Germans had emigrated.

In 1905, City Park was renamed Schiller Park. In June of that year, a celebration commemorating Schiller's death in 1805 began at Washington and Broad Streets, and five thousand people marched to the newly renamed park for a day of festivities.

Only thirteen years later, in 1918, Schiller Park was renamed Washington Park in response to anti-German sentiments stoked by World War I. (Can anything sound more American than Washington?) At this time, the South

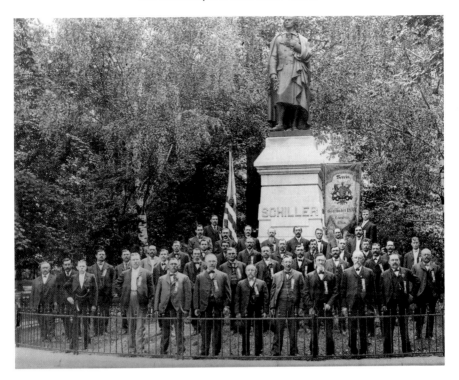

A Suabian Beneficial Society gathering, possibly at the 1891 Schiller Statue dedication in Schiller Park. *Courtesy of the German Village Society Fischer Archives.*

End also listed a Schiller Street near the park. This, too, was changed, and today's residents of that street refer to it as Whittier. The park went by the name Washington until 1930, when it was once again renamed.

Perhaps the most mysterious event to happen in the park was the disappearance of the original Umbrella Girl Statue in the 1950s. To date, we still have no word of her whereabouts.

Fast-forward to 2006. Schiller Park, which has been listed on the National Register of Historic Places, seen $1 million in improvements, met a new Umbrella Girl and hosted Shakespearean actors and "dead headers" (planters in gardening gloves not hippies in tie-dye), is still revered as a treasured and well-utilized public park.

For that, we owe thanks to the Stewarts, the Deshlers, the Thurmans, Captain Otto, the City Department of Recreation and Parks, the Friends of Schiller Park and, of course, the residents who use the park daily.

AN ADDRESS TO ENVY

German Village truly has it all—when it comes to architecture, that is. (And pretty much everything else too, right?) We see the brick and the frame, the story and a half and the Queen Anne and even catalogue homes. But did you know that German Village also has a WPA building?

WPA stands for Works Progress Administration, a part of the Emergency Relief Act passed in 1935 to bolster the economy. The Emergency Relief Act was part of President Franklin Roosevelt's New Deal, and its aim was to help Americans cope with economic hardships brought on by the Depression.

The WPA was the cream of the New Deal's crop. It provided work to unemployed Americans—black and white, male and female—in every

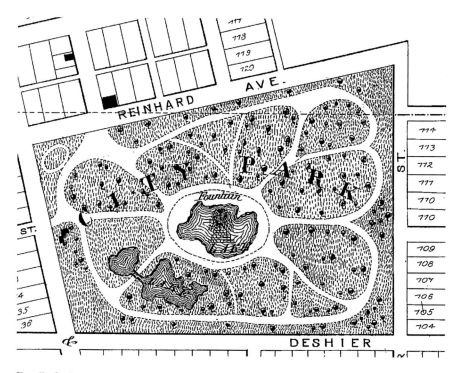

Detail of what was then called City Park and today is Schiller Park, 1872. Very few houses were built around the park at this time, but address numbers had been identified for lots on Jaeger Street (right). The present-day carriage path in the park follows the historic footprint evident here. *Courtesy of the German Village Fischer Archives and 1872 map of the South End of Columbus.*

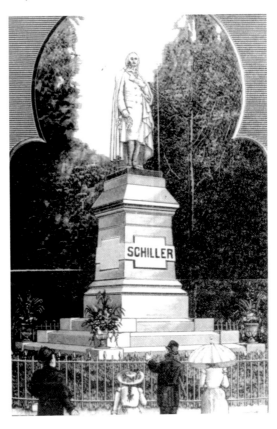

Sketch of the Schiller Statue, undated. *Courtesy of the German Village Society Fischer Archives.*

state, and it resulted in the nation having an incredible collection of federal buildings, county courthouses and bridges, to say the least.

WPA officials hired unemployed Americans to work on government projects ranging from construction to the arts. While it was active from 1935 to 1943, the WPA constructed more than 600,000 public buildings, eight thousand parks and 850 airport runways. Workers documented the nation's historic buildings in the Historical Records Survey, catalogued art and historic documents and taught the illiterate to read.

Each state had a WPA office that worked with the national office, and hundreds of thousands of Americans were employed under the WPA. In Ohio alone, more than 173,000 men and women found jobs.

By 1938, Ohio's WPA workforce had improved 12,300 miles of roads and streets and constructed 636 public buildings, several hundred bridges, hundreds of athletic fields and five fish hatcheries. Improvements were also

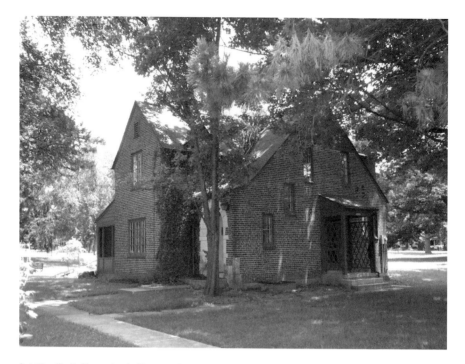

Schiller Park Caretaker's Cottage, June 2008. *Photo by author.*

made to hundreds of existing buildings, roads and parks. And many of the post office murals for which WPA artists became known were completed or underway in many Ohio cities and towns.

Adding to that list was the caretaker's residence in Schiller Park. Built in 1935, it would have been just three years old in 1938, when all of the above work was completed.

The 1935 *Annual Report of the Division of Parks and Forestry* states the following about Schiller Park:

> *Still gaining in popularity, 121,452 persons enjoyed the shelter house during the year. Two croquet courts were built on the north side of the park and proved very popular with the older groups. Through the cooperation of the South Side Civic Association, new entrance ways are being built of limestone. WPA is furnishing the labor, the city, the limestone, and South Side Civic Association, the cement, sand and lime.*

The old caretaker's residence is being replaced by a new six-room brick, the city furnishing part of the materials, and the labor is being furnished by WPA. This is a much-needed improvement as the old house was beyond repair.

That's right. In a neighborhood known for miniscule backyards, one resident's was twenty-three acres.

I may be way out on a limb, but I think it's a safe bet that some German Village residents were the WPA workers building the new caretaker's residence. Although Columbus didn't fare as badly as other cities during the Depression, it certainly took its share of hits that left many unemployed. It's hard to imagine that the South Side would have been an exception.

About the old caretaker's house that was replaced by our WPA structure, it should be noted that the 1891 Sanborn map shows a two-and-a-half story dwelling at 1000 City Park Avenue, right about where Stewart Avenue dead-ends into the park today. The dwelling faced north to Reinhard Avenue, and there was a porch across the front. Old photographs show what appears to be a brick and frame building. A carriage path was in front of the building, and the original Umbrella Girl Statue was near it as well.

The beauty of the WPA was that its workers created buildings and spaces to be utilized by the public. Considering the public use that Schiller Park gets, I'd say the building has done its job.

Although it was lived in for quite some time, today the Caretaker's Cottage is used by Actor's Theatre for meetings and storage, and given the enjoyment the neighborhood gets from Actor's Theatre, I think we've made good use of the building.

THINKING "OUTSIDE THE BOX": THE BEAUTY OF OUTBUILDINGS

Everyone knows that homes in German Village are some of the most beautiful and intriguing in Columbus. It simply goes without saying. But one thing I can add is that German Village and Columbus have some of the most fantastic outbuildings around.

Outbuildings, you ask? The beat-up old garage on your alley, the weird and decrepit-looking shed in your yard and, yes, even the privy that so few of you still have in your backyards; believe it or not, these buildings say as much about the neighborhood as some of our most spectacular houses.

Some of the earliest outbuildings would have been privies, or outhouses. Fortunately, our neighborhood still has a few left, but those numbers are dwindling. After all, who thinks to keep an outhouse in the backyard? But for those who have kept them, I imagine you've got icebreakers and conversation-starters galore at parties!

Few things remind us of our history like the thought of life without indoor plumbing. As if our historic homes don't do the job well enough, seeing an outhouse will certainly remind anyone of how long ago a home was built.

The German Village Society's collection of Sanborn Fire Insurance maps show the footprints of buildings in 1891, 1901, 1922, 1951 and 1971, and there are numerous outhouses visible on the 1891 map. They aren't labeled as such, but what else could the tiny structure just a few feet from the house in just about every yard possibly be?

Even more interesting to me than privies are the historic stables and garages. Many of the neighborhood's early outbuildings were stables (and probably were too large to be referred to as outbuildings, but for simplicity's sake, I'll do so). Fortunately, some are still standing.

Obviously, stables hail from the days before automobiles. Businessmen used horse-drawn wagons and carriages for work, and residents drove carriages instead of cars. G. Michael's was a stable, as was the red building across the street from Schmidt's, formerly called the Red Stable and today housing Mars Creation.

(Adding an even cooler level to the outbuilding discussion, I learned on good authority from Mr. Philip Kientz that the Red Stable actually was an icehouse, and its interior walls are insulated with cork.)

A few historic stables still stand behind homes on Deshler and Thurman Avenues, and although they look rickety by today's standards, they've stood a lot longer than most garages in the neighborhood ever will.

Some stables even retain some of their original design details. The German Village Auto Haus on Macon Alley still has a hook that would have been used to get hay into haylofts. Windows on the second floor still have

their signature casement style, and barn doors ran on rails to slide open vertically, rather than above like modern garage doors.

Unfortunately, I don't know the history of this building, but it must be fascinating. The first floor is currently stone block, and the historic frame stable has been kept above it. It is strange looking for sure, but some history has been saved, so the building gets an A+ in my book.

Carriage houses provide the same mystique as stables, but in a more elegant fashion. These were most commonly affiliated with grand homes, whose original occupants could afford a carriage. So for anyone with a story-and-a-half cottage who is thinking about adding a carriage house, think again. These were typically reserved for the larger Italianate and Queen Anne homes.

Similar to remembering life without indoor plumbing, historic stables and carriage houses remind us of life before the automobile—almost as hard for me to imagine!

The 1922 Sanborn Fire Insurance maps show the earliest garages, or "auto houses," behind properties in German Village. In the 1951 maps, we have an explosion of garage construction.

The early garages were often flat roofed and built of frame or stone blocks. The earliest were, of course, for one car, and some of the most successful modern garages use the one-car look as a model for today's two-car needs.

These historic outbuildings, much like our homes, tell a story. When a historic map shows a stable for years and then suddenly shows a garage on the same site, it's clear that a pretty big life change was made. That seemingly small image on a map indicates a family or business transitioning from horse to automobile for its transportation needs.

So care for these old outbuildings. They are unique and tell a story of your home's past. Even the privies!

CITY PARK AVENUE HISTORY WELL RETAINED FOR FUTURE GENERATIONS

One of the earliest houses in German Village to be restored in the 1960s was 559 City Park Avenue. Charter Society members Ralph and Dorothy Fischer

"Another German Village Restoration." No. 559 City Park Avenue, post-restoration by Ralph and Dorothy Fischer. *Courtesy of the German Village Society Fischer Archives.*

No. 559 City Park Avenue, pre-restoration by Ralph and Dorothy Fischer. This photograph highlights a front porch that was later removed. *Courtesy of the German Village Society Fischer Archives.*

worked their magic on City Park Avenue and took incredible photographs to document their work.

The Fischers bought the house in March 1961, restored the exterior only and sold it in July of the same year, making $6,000, a profit Dorothy noted was "dazzling" at the time.

And this was the not-so-glamorous start of our neighborhood's revitalization, as is so common in other historic districts throughout the country. We celebrate our Society's charter members and love hearing the stories of what they did and why, but there really is little romanticism in the origins of today's German Village.

The charter members and earliest investors very often did bare-bones work, and that was just perfect. They purchased a few homes, dressed them up, made their outer envelopes secure and left the rest of the work for the next caretaker in line.

As they worked, more and more homes got cleaned up, making room for more and more investors, who would become long-term residents, to do the rest. Resources were divided and utilized to their fullest; some had cash, some had an architectural eye, some had an artist's touch, but the end result was 233 acres of rehabilitated and revitalized German Village.

And a simple home like 559 City Park Avenue has the most basic of German Village stories to tell. Built between 1860 and 1880 (as so many of the Italianates in the neighborhood were), this home is a typical German Village home.

A family history I found online tells of the author's parents, Harry and Mary Cook, buying the house in 1944 for $3,000. His father worked at Schmidt's Parking Company and then went to night school to learn welding at Franklin University. He got a job at the Jaeger Machine Company, where he worked until he retired.

Remember that for much of its history, the South End was a working-class neighborhood filled with families who worked hard to build successful lives in Columbus. Large families were raised here, and strong values were expected and shared. And this wasn't common only in German Village—it was common of the time.

The author of his family's history at 559 City Park captured incredible day-to-day information about the neighborhood during his time here. He remembers ice being delivered to each home for the icebox. Customers would put a sign reading "Ice" in their front window with the number of pounds they desired. He remembers a vegetable salesman who drove up and down City Park Avenue, stopping every half block or so for residents to gather around his wagon. He remembers the coal deliveries and his after-school chore of having to load the coal into the basement through the coal door (that metal door often

seen on the front of German Village homes). The coal deliveryman charged an additional fifty cents to put the coal in the basement, but this gentleman notes that his father always saved that money and had his sons do the work.

I am so interested in the German Village that existed between the German immigrants and the preservation pioneers of the 1960s. I think our working-class, more American roots are just as important as those of the early German-speaking residents and their earliest construction in the neighborhood. It was the Germans who built our German Village, but their descendants and other working-class, downtown-living Columbus residents continued to take care of things. It was these residents of the 1940s who experienced our neighborhood during World War II and saw, and often participated in, the exodus to the suburbs that followed the war. They later saw Interstate 70 heading toward their neighborhood and had no idea how to react (thankfully, we do today).

We have so many layers of history in German Village and the South End, and each bears information critical to defining who we are and how we got here today. Each is worthy of better understanding and great appreciation, and each has contributed greatly to our staying power as a historic neighborhood and now fifty-year-old civic association.

Prost to those who lived in our homes before us, and prost to us today. Now, some preservation-minded people serve as caretakers for 559 City Park Avenue, and I know they are taking good care of it for future generations of villagers. Just as the Cooks and Fischers did for them.

COTTAGE LINKS SOCIETY'S PAST WITH NEIGHBORHOOD'S FUTURE

One of the most unique places in German Village is one that I would bet most people often overlook, even though many pass by it everyday. Known as "the little cottage," "the Oktoberfest office" or simply as "624," the story-and-a-half brick cottage at 624 South Third Street served for many years as the headquarters of the German Village Society.

Owned by the Stauch family for many years, the fledgling Society purchased the property from the estate of Ruth H. Stauch in 1961. With the cottage came the double behind it at 619 and 621 Lazelle Street, a property that the Society restored and used as two rental units.

No. 624 South Third Street when it served as the offices of the German Village Society Oktoberfest. *Courtesy of the German Village Society Fischer Archives.*

A 1968 Columbus vignette published in the *Dispatch* read:

> *The little house in the front was built in the 1860s. The other was probably added in the 1880s. In 1892 the tax valuation on the works was $1,780. By 1917, when owner Louisa Stauch died, its valuation was $2,930 and a year's taxes came to exactly $41.02. As late as 1960 valuation was only $4,330 and taxes were $118.64—on three living units! The Society paid $6,000 for the property then borrowed heavily to restore all three units.*

One 1965 article published about the earliest renovation projects in German Village declared the house at 624 South Third Street worthless when the German Village Society acquired it. The house had been vacant since 1917 and had, without question, seen better days.

Since taking ownership in 1961, the cottage has been used by the Society for commission meetings, museum space (using a fairly loose definition of museum), social gatherings, early Society meetings and as Oktoberfest headquarters. Most recently, the building has been a rental property.

Haus und Garten Tour–goers purchasing tickets from the front window of 624 South Third Street when it served as the headquarters for the German Village Society. *Courtesy of the German Village Society Fischer Archives.*

The cottage is classic German Village. A story-and-a-half brick cottage with a Gothic-arched window upstairs and a side/rear porch, the cottage stands at just under one thousand square feet and has a wonderful patio space in the rear yard.

A brick pathway links the cottage to the Lazelle Street double behind it, and when the Society owned both, the pathway and patio were used often to move from one restoration project to another or simply to host outdoor picnics.

Serving as a community space for the young and growing German Village Society, the building offered neighbors a place to go to volunteer, attend commission meetings, plan for the Society's future, buy Haus und Garten tickets or just visit. It sounds a lot like our current Meeting Haus, doesn't it?

As one might imagine, our organization, which started with just a dozen members and quickly grew to more than several hundred, eventually outgrew the little cottage, and for that reason, it was used only as office space for Oktoberfest planning. The ability to move just one block north into a larger building was ideal for our nonprofit civic association, and with the purchase of 588 South Third Street, the German Village Society became the owner of two distinct and historic properties.

Ultimately, the cottage at 624 South Third Street was sold to the highest bidder—a Society trustee and gentleman with true affection for the place where the Society got its start. After several years, he sold it to another caretaker, who has made it his home and cares for the property as lovingly as the Society could possibly hope for.

The cottage has been here for more than 150 years, and it's still got a lot of life left in it.

Remembering the "Haus" History at Third and Willow

Each August we remember the birthday of the German Village Society Meeting Haus, a building that we use for regularly scheduled committee meetings, countless community events, tours, yoga and, of course, the monthly German Village Commission meetings.

No. 588 South Third Street, German Village Hall. *Courtesy of the German Village Society Fischer Archives.*

But the Meeting Haus has a history that goes beyond just being a headquarters for the German Village Society. This is a historic building in its own right, and its past should be celebrated as much as its present.

In 1891, when St. Mary's was known as St. Marien and the Third Street School (Golden Hobby Shop) was known simply as Public School No. 6, the building at 588 South Third Street was a two-story brick double that sat square in the middle of a large lot on the corner of Willow Street that also housed a wagon-making and painting building and stable whose address was 122 Willow Street.

By 1901, not much had changed. The Wallsmith Brothers Wagon Shop was expanded ever so slightly, connecting the wagon-making building to the stable. And two outbuildings for lumber storage were on the site as well. The double stayed as it was. But changes were coming.

By 1922, the building at 122 Willow Street had been changed to a footprint similar to what we see today at the Meeting Haus. The walls were

all eighteen inches thick, the building had a Lodge Room and the roof was a mix of slate and shingle. However, this was a brand-new building; all of the information provided was from plans, meaning that our building was constructed sometime after 1922.

(Incidentally, the two-story brick double was long gone by this point. The lot was split, and the building that currently sits at 592 South Third was built.)

The Lodge Room in the building was used by the Fraternal Order of the Moose, which owned and occupied the building until 1942. That year, the order traded buildings with the Woodmen of the World, which owned the building until 1959, when it became Tom Littleton's sign company.

Aside from the construction of a new building in the 1920s, the next biggest change to our humble Meeting Haus came under Tom Littleton's ownership. This change was our address. Littleton excavated some of the site and added a concrete block garage and parking lot that forced our street address to change from Willow to South Third.

That being said, we often direct people through the Willow Street entrance for events. Next time you cross that threshold, remember that it used to be our front door.

The German Village Society purchased the building at 588 South Third in 1987, and we haven't looked back since. We had a successful enough capital campaign to renovate our building and make it debt-free, an enormous feat for a nonprofit organization.

Really, really enormous.

Today, the building is used for just about everything under the sun, but even though it is debt-free, that doesn't mean it's free and clear. Our Meeting Haus sees lots of foot traffic. On top of the list mentioned above, our building is the evacuation headquarters for St. Mary School, so we've got feet of all sizes contributing to the traffic.

But we're a community center of sorts, and therefore we should have heavy foot traffic because that's a sure mark of an active community.

In the tradition of the fraternal organizations that used the building first, our Fest Hall was the site of one of the earliest Society meetings in the 1960s and still sees a lot of action today.

In 2005 and 2006 alone, we had two birthday ice cream socials, the Village Seen, Cookie Caper, our annual meetings, our Oktoberfest volunteer

spaghetti suppers, the Caretakers of a Legacy Award receptions, a couple dozen Buckeye tailgate parties, a pancake breakfast, Actors' Theatre's attempt at the *Guinness Book of World Records*, Village Singers concerts and no less than a lesson from an expert gardener by the name of John Carloftis. Plus, weekly regulars like yoga classes.

Need I say more?

So while I regale you on an almost weekly basis to care for your buildings, please take the time and effort to help us care for ours. Let's make sure the Meeting Haus's future is as notable and interesting as its past. In 2008, the Fest Hall was officially named the Brent Warner Fest Hall in honor of a member with incredible devotion, foresight for our Society's finances and passion for historic preservation. Or perhaps it was named for Brent because he attended each event in the room with renowned love for his neighborhood. Either way, the new name is just one more layer in the story and heart of our gathering space and community center.

THE TIES THAT BIND PHARMACEUTICALS, STAINED GLASS AND ITALIAN CUISINE

The Franklin Art Glass Studio is known locally, nationally and internationally for the incredible artwork produced in its studios.

Made in America and John Ratzengberger were right to feature this local business on the Travel Channel in 2006. The nationally renowned business is a local institution, to say the least.

But there is more to it than stunning stained glass. In this case, there are the "five degrees of separation." This single business is linked to several other buildings and businesses in the area, so here is my two cents worth of press coverage.

An Ohio Historic Inventory states that the building at 222 East Sycamore was built in 1922 as a U.S. Armory, and while this would be fascinating to me, I haven't found any other sources to back up that information.

Rather, my 1922 Sanborn Fire Insurance maps show an enormous building stretching from Sycamore to Gear (today Lear Street) at 222–224 East Sycamore. The business was the Walter L. Lillie Company, and it manufactured furniture, picture frames and novelties. The building included a mill room, lacquer room, varnish room and office.

This was a commercial pocket within the neighborhood. Just two lots down, at 251 Gear, was an auto-repair garage, and directly across from that, at 244–248 Gear, was the John Herrel & Sons Company, which manufactured refrigerators.

By 1951, building and business expansion had forced a plumber's office and dwelling to be demolished, and Whole Drugs took over for the Walter L. Lillie Company, occupying the building whose address now stretched from 222 to 226 East Sycamore.

By 1971, the building was labeled as an art glass manufacturing company, and we're back to Franklin Art Glass Studio, a business that has been in German Village since the 1960s. But there's even more to it than that.

Franklin Art Glass Studio founder Henry Helf got his start in the stained-glass business as a foreman for Theodore and Ludwig Von Gerichten in their Von Gerichten Art Glass Company. No minor player in the world of stained glass, Von Gerichten was the largest stained-glass studio in the United States by the 1920s.

Theodore Von Gerichten was the company bookkeeper, and he lived initially at 366 East Kossuth Street and later at 117 East Deshler Avenue. Ludwig Von Gerichten, the company's president and art director, lived at 181

No. 117 East Deshler Avenue, Von Gerichten House. This photo was likely taken on the Fourth of July. Note that Deshler Avenue was not yet paved. *Courtesy of Theodore Von Gerichten IV.*

Thurman Avenue. The latter two addresses are in what is now considered German Village.

The Von Gerichten Art Glass Company was located at 555 South High Street, a building that today houses Tony's Italian Restaurant.

The Von Gerichten brothers couldn't quite hurdle the Depression, and when given the opportunity, Helf purchased the remains of their studio and incorporated it into his Franklin Art Glass Studio.

Countless churches in Columbus and throughout the United States are fortunate to have Von Gerichten stained-glass windows, and thousands of homes, businesses and churches have Franklin Art Glass Studio's fine work.

This business not only maintains a craft steeped in history and art, but it also supports the neighborhood's urban quality of having businesses tucked next to residences. Like so much in German Village, the story of 222 East Sycamore blends Old World charm with a contemporary art and livelihood.

So it's five degrees, and not the traditional six degrees, of separation. How fortunate are we as a historic community to have buildings with such strong ties to the past!

FAMILY-OWNED RESTAURANT KEEPS VISITORS COMING TO GERMAN VILLAGE AFTER 120 YEARS

"Can you tell me how to get to Schmidt's?" This is no doubt a familiar question for anyone living in German Village—and justifiably so.

Our neighborhood's unique businesses make it a destination for visitors from far and wide, but this business in particular has stood the test of time like no other. The Schmidt family has clocked more than 120 years in the food service industry in German Village, and they show no signs of slowing down.

In 1886, German immigrant J. Fred Schmidt formed the appropriately named J. Fred Schmidt Packing Company at 253 East Kossuth Street in Columbus's South End, the current site of the Schmidthof Condominiums. The slaughterhouse and sausage factory was made up of several buildings, sheds, stables and corncribs.

J. Fred died at a young age, and his wife, Lena, took over the business while raising their five children. Son George L. Schmidt took over the packing company when he was only fifteen years old. The packinghouse featured

George L. Schmidt in front of the Schmidt family's commercial packinghouse at Jaeger and Kossuth Streets. *Courtesy of Geoff Schmidt.*

eighty varieties of meat, but its specialty was meat prepared with recipes that J. Fred brought with him from Germany.

By this point in time, the building that currently houses Schmidt's Restaurant and Sausage Haus had not yet been built. Standing at the jog in the road where Kossuth meets Purdy was a collection of smaller buildings: a corncrib, a rag storage shed, a house and a stable.

George L. retired in 1941, and his oldest son, Fred, took over the business. When Fred died in 1952, his brothers Grover and George F. Schmidt ran the business together.

The beef packing plant was forced to close in 1964 as a result of grocery store price wars and laws against keeping livestock within the city limits. By 1966, the pork packing plant had also closed. When the plants closed, the Schmidt family employed more than ninety people. These closures brought about the next step in the Schmidt family business: a retail meat deli.

The brothers sold the packinghouses at the corner of Kossuth and Jaeger Streets but kept a livery stable they owned around the corner. The stable had been built sometime in the 1890s, and the Schmidt family had purchased it in 1937 for storage.

In 1967, the South Side neighborhood recently named German Village was just beginning to come back into its own. In his wisdom, George Schmidt thought a retail deli specializing in German food made perfect sense for the old German neighborhood. That up-and-coming feeling in the neighborhood plus the family's roots in Kossuth Street created a dream combination for both the family and a neighborhood trying to attract visitors.

The deli and restaurant took off quickly, forcing Grover and George Schmidt to expand their business into both the upstairs and downstairs of the renovated stable. Following a vacation on Mackinac Island in Michigan, George thought the idea of a fudge shop would work well for the neighborhood, and in 1970, the family opened Schmidt's Fudge Haus at the corner of Kossuth and Fifth Streets.

In 1980, George's sons Andrew, Geoff and John bought their uncle Grover out of the business, and this fourth-generation of Schmidts still runs the family business today.

Schmidt's has no doubt brought great times and great people to German Village, and the Schmidt family legacy here overlaps with so much of our neighborhood's legacy as a whole. May the fifth generation of Schmidts have as much success and neighborhood pride as their predecessors!

IF WALLS COULD TALK, THIRD AND FRANKFORT IS WHERE I'D BE

In 1958, the South End of Columbus wasn't nearly what it is today. There was no such thing as German Village, and the first Haus und Garten Tour was still a year away.

But it was a big year for our neighborhood because it was a big year for Max Visocnik. The year 1958 was when he purchased and revamped Slim's Tavern; it was also the year that Max & Erma's was born.

The building at 739–741 South Third Street has a long history as a commercial property. In 1889, the three-story Lamprecht's Hall was

completed at the corner of Third and Frankfort by Tobias Lamprecht. Tobias ran a grocery store and saloon on the first floor, his family lived in apartments on the second and a social hall filled the third. Tobias's niece Annie Rippel tended bar for her uncle and helped her mother make chicken soup for saloon customers.

When Lamprecht died in 1903, Annie and her husband, August Kaiser, ran the family business, and the building became known as Kaiser's Hall. The building served as a community gathering space that offered fresh produce for sale, a turkey raffle at Christmas and staples for all household needs in the South End. The building was a destination for anyone traveling south on Third Street and often hosted concerts for German singing groups in the third-floor hall.

Even through the difficult anti-German years and Prohibition, Annie and Gus Kaiser kept their business open (likely selling near beer). Gus died in 1922, but Annie kept the business at 741 South Third Street. A grocer moved into 739, and Annie continued to live in the upstairs apartments, taking on boarders and providing living space for some of the downstairs grocers.

In the 1930s, the third-floor hall was used frequently by the Franklin Brewer's Union for meetings. By the 1950s, the Weber and Spanovich Restaurant was on the first floor of the building, having taken over the grocery space. Once Weber left the restaurant partnership, Spanovich renamed the restaurant Joe's Inn Restaurant. After Joe's Inn's limited success, Paul "Slim" Jones ran Slim's Tavern in the space, but only for one year.

Even though a variety of businesses filled the space, the bar at 739–741 South Third Street had loyal customers. One such customer was Max Visocnik. As an employee of the Franklin Brewery, Visocnik had attended union meetings in the hall and delivered cases of Ben Brew Beer to the establishments on the first floor of the building. While he was courting his girlfriend, Erma (who, incidentally, lived just on the other side of Third), the two would often walk across the street for a drink at Slim's.

After serving in World War II, Max took a job with Franklin Brewery but realized quickly that he wanted to own a tavern. In 1958, he and Erma bought Slim's. Erma retired her apron as the bar manager at the Southway Post of the American Legion and joined Max behind the bar at their newly renamed watering hole at Third and Frankfort.

There were two taps serviced by the August Wagner Brewery. For a dime, you could stop in and get a pilsner full of Augustiner or Gambrinus. At that time, it was more bar than restaurant, and Max & Erma's was a place known for its casual atmosphere, neighborhood conviviality and engaging owners.

In 1972, Max and Erma sold the bar to Todd Barnum and Barry Zacks. Recalling the sale later, Max chuckled and said, "I marked a price on a piece of paper and put it in a sealed envelope. There was no squabblin'. They gave us our price. I tell you, if I'd known that, I'd have added on some more."

One stipulation of the sale, however, was a lifetime supply of free beer for Max at the bar. Not a bad deal.

Barnum and Zacks renovated the bar, considered giving it a new name (but didn't) and ultimately opened franchises throughout the Midwest, making Max & Erma's a much bigger entity than the four walls at 739–741 South Third Street can ever contain.

And after the sale of their business, Max and Erma Visocnik moved from their apartment above the bar and settled into a ranch house in southwestern Franklin County. Erma died in 1977, and eighteen years later, Max joined her.

But both still live on in German Village. They established a presence in our neighborhood just as momentum was shifting and people were paying more attention to the South End. They managed a building that was built to be a tavern and, like shop owners of years past, lived above it.

Most importantly, they offered a place for the social roots of this neighborhood to take shape and gave people a place to go. Prost to Max and cheers to Erma for adding to generations of tall tales told at the bar at Third and Frankfort. Our neighborhood wouldn't be the same without them.

South End German Built Home for His Family and the City's Most Honorable

There is some debate about this, but it appears that the builder of the Senate Building on Capitol Square lived here in the South End. At the corner of Fourth and Deshler to be exact.

Friedrich Wittenmeier was a master stonemason who led the trade in his day. He built his house at 147 East Deshler Avenue in 1884, after picking one of the

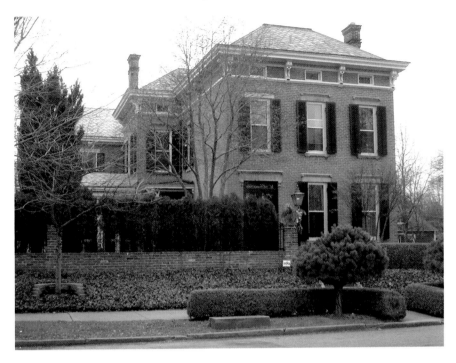

No. 147 East Deshler Avenue. *Courtesy of the German Village Society Fischer Archives.*

choicest lots in the South End. The house is ornate and reflects the grandeur that led to people referring to Deshler Avenue as the "Dutch Broadway."

Mr. and Mrs. Wittenmeier had eight children—four boys and four girls—and had room in their house for two maids. In all, the home housed twelve. It was exceptionally modern for the time, likely given to Mr. Wittenmeier's work and that of associates he met on large-scale projects.

The home had its own water system, which was unique in the late 1800s, and had bathrooms both upstairs and down. A huge water tank stood on the third floor, with a pump that went down to the basement; according to the Wittenmeier children, the tank took hours to fill.

A large brick stable stood behind the house and was connected to the main building with a thick grape arbor. Mrs. Agnes Wittenmeier took great pride in her gardens (both vegetable and flower) but was sure to leave room in the backyard for a chicken coop for fresh eggs.

Once he had finished building his family home, Mr. Wittenmeier moved on to a larger project. In 1899, Wittenmeier is said to have started work on the new

Supreme Court building on the east side of Capitol Square. The statehouse had become too crowded for the audiences that both the legislature and the Supreme Court commanded, so a new building had been commissioned.

Constructed of the same Ohio limestone that makes up the Greek Revival statehouse, the new Judiciary Annex took only two years to build (unlike the statehouse, which took eleven times as long). The main reason this building took so much less time to construct was its style. The statehouse is a bunker of sorts; the Judiciary Annex was built with a lighter metal skeleton between 1899 and 1901.

The debate over this building's mason comes from two differing sources. One says that Friedrich Wittenmeier can claim credit for the annex and subsequently went broke in constructing it because the city and state could not afford to pay him. Another says that Cincinnati architect Samuel Hanaford built the annex.

I can't bring any authenticity to either argument, but I do like thinking that a local German had a hand in one of the city's most prominent buildings. So without any additional information presented (or research conducted), I'm happy assuming that Mr. Wittenmeier was the lead mason.

Legend has it that Mr. Wittenmeier lost his family home because he was never paid for his work on the Judiciary Annex. Many families have owned it since and made their mark on this high-style Italianate house.

Today, the former Judiciary Annex is referred to as the Senate Building, and thirty-one of thirty-three state senators keep offices inside. In the late 1980s, the building was fully restored, and it was opened for use by the senate in 1993.

As you walk or drive by the Judiciary Annex downtown, take pleasure in the fact that an early villager very likely had a hand in its construction and, without question, made a mark on Deshler Avenue with his family home.

PreTour Sites Offer History Lessons over Dinner

German Village's big weekend is planned with incredible care and countless hours each year, and while the German Village Society staff and Haus und Garten Committee volunteers are hard at work in the eleventh hour crossing the

t's and dotting the *i*'s, it is fun to take a minute to look back and see what some of the featured homes were in their earlier lives. With just a quick skim of the PreTour invitation, loads of interesting neighborhood history jumps out at me.

Several of our businesses and their unique commercial architecture will be showcased: Bakery Gingham, Brown Bag Deli, DesignSmith, Easy Street and Pistachia Vera (and I don't know about you, but I love that Amanda Ellis of Bakery Gingham has kept the hanger on her front door in homage to the space's former use as a dry cleaner).

And then, of course, there are the buildings with unlikely commercial history and usage: the German Village Guest House and Keny Gallery, which are businesses but in obviously residential structures, and Andy Schiffman's dinner at 133 East Beck Street, which is a residence but in an obviously commercial structure (Silberman's Grocery).

There are several PreTour dinner locations that showcase the opportunities for new construction in and around our historic district: the home at 639 Mohawk Street, which was showcased two years ago for our PreTour cocktail

A typical family dinner at Roxie Chamber's home at 121 East Whittier Street. *Courtesy of Roxie's granddaughter, Lynn Chambers Lust, and former residents of 121 East Whittier Street, Ralph and Julie Nusken.*

party; the home at 184 East Beck Street, which respects those surrounding it so well; the Treetops at German Village on South Pearl Street, which might have some of the best views of our fair village around; and the home at 179 East Deshler Avenue, which complements those around it while enjoying spectacular views of Schiller Park. Each of these projects will show diners just how precise, diligent and deliberate new construction projects are in German Village. After all, they will be forever compared to our historic building stock, and those are high expectations to live up to.

One PreTour home was occupied by the same family for nearly one hundred years. Adam Fornof was born in Wersau, Dieburg, Hesse-Darmstadt, Germany, and lived with his family at 67 Deshler Avenue. Fornof survived the horrors of the Andersonville Prison Camp (Georgia) during the Civil War, but perhaps only by chance. Fornof was taken with other soldiers for a prisoner exchange, but as there were not enough Confederate soldiers to exchange, he was one of the Union soldiers ordered back to Andersonville.

He remarked later in life that one experience in that prison was enough, and he was determined never to go back alive. He managed to escape while on the way back to the prison, but being unfamiliar with the territory, he wandered for four days before realizing that he'd traveled in a circle. Fortunately, he found his regiment and was thereafter discharged and naturalized as a United States citizen.

When Fornof died in 1912, he left his home to his son, Peter, who then left the family home to his sister, Katharine. Katharine never married and lived at 67 Deshler Avenue until her death in 1974, at which point the house was sold as settlement of the estate and, for the first time since its construction, occupied by a person outside the Fornof family.

Another PreTour dinner site was the longtime home of a local political activist and big-time family matriarch. Roxie Chambers, of 121 East Whittier Street, moved with her husband, Boston Chambers, into their home shortly after they were married in 1903. Her husband died shortly thereafter, and Roxie took in boarders to help bring in enough income to raise her two children in the house. She directed talent shows at Stewart Avenue Elementary School, was a charter member of the Republican Women's Glee Club when it was formed in 1923 and worked as an assistant for Mayor Rhodes. In her seventies, Roxie was heavily involved in Eisenhower's campaign for the presidency and attended his inauguration in Washington, D.C.

From a family account given to the Society several years ago, Roxie had as much character and personality as her name implies, and the Chambers family shared many boisterous meals around her table.

Each of this year's dinner locations has a unique story to tell, as will each dinner itself. And remember, what happens in German Village stays in German Village!

Hauses und Gartens on Fiftieth Annual Tour Packed with History

What makes our Haus und Garten Tour so unique is the fact that visitors get to enjoy inspiring architectural features and decor but also the history that each of these sites exudes. Our tour of inspiration lets people see what can be done with a lean or hefty budget and what our historic homes look like when lived in by one adult, a few or a handful of kids. The tour lets visitors see that it's not a completely off-the-wall idea to move into a historic home in a historic district.

The 2009 tour included terrific highlights, but a personal favorite was 80 East Sycamore Street. The garden was featured on the tour, so I will include here some information about the house that was not included in the program write-up.

The Franklin County auditor's website lists the earliest owner as Anna Kaiser, a name I became familiar with when I did some digging on the Max & Erma's building. It seems that Anna and her husband, August (Gus), owned the building at the corner of Third and Sycamore in 1920 while they operated Kaiser's Hall (saloon/grocery) in what is today the Max & Erma's building. I can't find the dot connecting the two, and I'll admit that the names Anna and Gus Kaiser may have been common in the South End in the 1920s, but I'm going with my gut to say that they are one in the same.

When the Kaisers owned the property, it still retained its original address of 659 South Third Street. Early maps show that Sycamore Street (which was originally College Street) was its current width until it hit City Park Avenue, where it narrowed incredibly. At that time, a cottage stood at no. 659, and a two-story home stood at 665 South Third Street near the corner of the very narrow College Street. When College/Sycamore was widened,

the house at 665 South Third was demolished; likely about that same time, a cottage was built so close to 659 South Third Street that the two shared a wall. Ultimately, this building became 659–659½ South Third Street, today known as 80 East Sycamore Street.

Rumor has it (I know, I know, more unsubstantiated information that I, as a historian, shouldn't be relying on but do so in the name of interesting local history) that in the 1960s, Dorothy Fischer owned the property and loaned the basement to the fledgling German Village Society to use for meeting space.

Great information, except that the transfer history never shows Dorothy as an owner. Dorothy and her husband, Ralph, lived in the home immediately south of Katzinger's for years, and it is their collection of photographs that makes up the Society's Fischer Archives. Dorothy led tours, was an early treasurer of the Society and volunteered for just about anything she was asked to do. There is no doubt in my mind that if she did own the property, she would have made it available for Society use. So again, I'll accept this information in the name of interesting local history.

At least one side of the structure was used as the headquarters for the Columbus Women's Bowling Association in the late 1960s. Where they bowled, I have no idea—maybe at Deibel's? But apparently they met in this Third Street cottage.

By the 1950s, the property was listed as 659 and 659½ South Third Street and 84 East Sycamore Street. In its more recent history, the two cottages were obviously combined, and some of our neighborhood's most noteworthy preservationists owned the structure. The house was on the 1994 Haus und Garten Tour as a work in progress and then again in 1995 as a completed restoration. Steve Shellabarger gets credit for both of those tours. In the 1994 tour program, Mr. Shellabarger noted that while he had renovated several homes in the village to that point, the one at 80 East Sycamore was his most interesting project

Today, Dr. and Mrs. Season serve as caretakers of 80 East Sycamore, and I'm quite sure they have treasured its quirks, fantastic location across from St. Mary's and unusual history.

So there you have it. Two cottages that are now one, one address that has been at least three, a residential structure with an athletic past and one very historic haus that holds a unique spot in the history of the German Village Society—an ideal stop for our Fiftieth Annual Haus und Garten Tour.

After Forty-nine Years, Haus und Garten Tour Is Still Going Strong

Only half a century ago, many changes were taking place. Alaska and Hawaii were admitted to the United States as the forty-ninth and fiftieth states, Barbie made her debut into society and the Guggenheim Museum opened its doors in New York City.

Amidst all of this, a group of unassuming Columbus residents was organizing a tour of homes. The tour was to showcase renovated houses in the city's South End, and maybe, if they were lucky, people would be inspired to tackle other South End projects.

As luck would have it, people got very interested in the South End and in the newly dubbed German Village.

If you'd like to recreate the first German Village Haus und Garten Tour, here is the list of your tour stops:

576 South Third Street
660 City Park Avenue
41 Sycamore Street
693 City Park Avenue
44 Stimmel Street
780 South High Street
41 Columbus Street
820 South Fifth Street
216 Mithoff Street
914 City Park Avenue.

There was a band concert and art exhibit in Schiller Park, and tickets cost one dollar.

Our first tour got a fair amount of buzz, simply because people were so curious about homes in the South End. The area had seen some hard years (more like hard decades), and as a result, there were many vacant properties and unkempt rental units. The South End wasn't exactly known for being a showcase neighborhood.

Yet, people came to the tour and realized the neighborhood's potential. Property could be purchased for reasonable prices (like $5,000 reasonable) and rehabilitated fairly easily.

As the years progressed, our tour format took shape. We encouraged people to start their tour at whichever house they chose rather than follow a specific tour route. We acknowledged previous tour homes with signage, offered tram rides, asked that women not wear spike heels and featured an artist at each tour stop.

And we continued to tour on the last Sunday in June.

Our general rule of thumb: if it ain't broke, don't fix it. And we haven't. How amazing that something can work so well that after forty-nine years very little has been changed.

Numerous homes have been on the tour multiple times. I love going on site visits and seeing front doors with three or four of the bronze plaques that homeowners receive for being a stop on the tour.

And I love that our neighborhood has evolved so much that the same house can be on the tour several years and be completely different each time. And I'm not just talking new décor. There are a handful of tour homes that have been "works in progress" and have showcased new additions, gardens and renovations on later tours.

The neighborhood as a whole has taken enormous steps in just five decades, and we owe this, in large part, to that very first Haus und Garten Tour.

STREET NAME HISTORIES

We all agree that German Village is a pedestrian-oriented community. And I think we would all speak to the importance of our neighborhood's local history. That being said, I'm wondering how many German Village locals know the history of the streets we walk each day.

Most people know that the more German street names in our neighborhood were changed during World War I in the midst of rising anti-German sentiment. So, for example, Bismarck became Lansing and Schiller became Whittier.

However, streets named for local Germans usually held on to their historic names.

FIESER STREET: Where is Fieser Street you ask? It runs north–south between Mohawk and Macon, but the portion between Beck and Jackson has been closed. There has been some confusion over the history of this street. Fieser appeared on maps of Columbus as early as 1856, although it wasn't labeled. It was originally called Water Alley, though it was changed to Fieser in 1950 in honor of Frederick Fieser, well-known son of Columbus. In 1843, Fieser joined Jacob Reinhard in producing *Der Westbote*, a weekly German-language newspaper that stayed in print until the First World War. Fieser stayed active in the newspaper business for forty years and was the longest-serving editor in the city. From 1869 to 1870 and 1872 to 1873, he served on the Columbus Board of Education.

FOURTH STREET: In 1856, this street stretched from Livingston to Beck in (Samuel) Parsons Addition; it was appropriately named Parsons in honor of the family. Once the land south of Schiller Park was developed, the section of Parsons that ran from Deshler to Nursery Lane was called Mozart Street in honor of Wolfgang Amadeus Mozart. By 1876, the northern section of the street had been renamed Fourth Street, while the portion south of the park remained Mozart. It was not until 1910 that Mozart was renamed Fourth.

The Parsons were one of Columbus's most prominent families. Dr. Samuel Parsons came to Columbus from Connecticut in 1811. Dr. Parsons served in the state legislature, and his son George became the city's first millionaire. It was another family member, C.H. Parsons, for whom the current Parsons Avenue is named.

FRANK ALLEY: This one is really tucked away—if you are familiar with Fieser, I'm impressed. If you also know of Frank, you really know your neighborhood! Frank Alley is short. It runs east–west between Kossuth and Columbus and is bound by Purdy and Grant. It was originally called Barth Alley, likely in honor of Reverend John Barth, who organized the First German Methodist Episcopal Church in 1843. Charles Frank served on the building committee for said church, and the street was renamed for him. There is no doubt a more colorful version of the drama behind that story, but this is all I know.

LATHROP STREET: A portion of this street appears on an 1856 map of Columbus and is labeled as Poor House Lane. Sometime between 1876 and 1886, the street was changed to Lathrop, likely to honor M.D. Lathrop, a Columbus real estate agent, notary public and publisher of the 1860 city directory. He was also contracted in 1858 to renumber each house in Columbus, a job that was surely tedious, but not thankless if he got a street named for him. Other local Lathrops include Dr. Horace Lathrop, a well-known Columbus citizen who died during the cholera epidemic of 1849; Uriah Lathrop, who was a surveyor and engineer of the Columbus and Harrisburg Turnpike, which was built between 1848 and 1849; and Miss Emma Lathrop, who was an instrumentalist and vocalist who performed with the Maennerchor in 1869.

PURDY ALLEY: Though this alley has been on maps of Columbus since 1872, it was not labeled as Purdy until 1901 (portions of it were called Park Alley as early as 1886). Purdy Alley may have been named for George H. Purdy of Delaware, Ohio. Purdy was captain of a regiment at Camp Simon Kenton with Alfred Emory Lee (who was a leading historian of Columbus and whose history of the city is still referenced today).

RIDGEWAY ALLEY: This one is a trick question. Today, there is no Ridgeway Alley, as it was closed and made private. Joseph Ridgeway was a prominent Columbus entrepreneur. Before the Civil War, he began producing machine parts for specialized foundry work. Ridgeway was elected to Congress in 1836.

BLENKNER STREET: John C. Blenkner and his wife immigrated to the United States in 1837 and moved to Columbus in 1846. John was the proprietor of the Lafayette Hotel, located at the southwest corner of High Street and Brewer's Alley, for three years, and he also was a brewery owner and manager, although he was never formally trained as a brewer. With George Michael Schlegel (a trained brewer), Blenkner, apparently a fan of alliteration, established Blenkner's Bavarian Brewery. Blenkner died in 1877, and shortly after his death, Second Alley, which ran along the brewery and had subsequently been named Reinhard Alley, was renamed Blenkner Street in his honor.

HOSTER STREET: The Hosters were another brewing family. Family patriarch Louis Hoster was born in southern Germany and trained as a brewer. In October 1835, he established a small brewery on South Front Street with George Herancourt called the City Brewery. In 1844, Louis Hoster's sons, Louis P. and George J., purchased half the business that then became Louis Hoster & Sons. By the late 1870s, Hoster's Brewery was the largest in Columbus.

In 1870, Hoster produced about 8,000 barrels of beer per year, and by 1877, he was producing about 15,000. By 1902, Hoster had brewed and sold more than 500,000 barrels of beer per year, becoming one of the largest breweries in the state of Ohio.

REINHARD ALLEY: The Reinhard family was a prominent banking and newspaper family in Columbus in the late 1800s. Jacob Reinhard was born in 1815 and arrived in Columbus in 1836 as an engineer on the National Road. In 1843, Reinhard printed *Der Westbote*, a weekly Democratic newspaper printed in German, with Frederick Fieser. The two men also opened Reinhard and Company Bank.

In 1852, Reinhard was elected to the city council and remained a member for twenty years. As a council member, Reinhard served on the finance committee for fifteen years and as council president for five years. Jacob Reinhard's son, Frank J. Reinhard, also was a banker and publisher of *Der Westbote*. In 1888, Frank Reinhard served as Franklin County auditor, and in 1894, he was an officer of the Great Southern Fire Proof Building and Opera House Company.

BRIGGS STREET: Briggs Street is one of the few streets in German Village whose name has not been changed since it first appeared on an 1886 map. Like so many others, this street was named for a prominent Columbus family. Joseph M. Briggs was Franklin County commissioner in 1880 and 1883, and in 1907, he sold the Old Harrisburg Pike to Franklin County for $8,000.

JAEGER STREET: Jaeger Street was not officially named on a map until 1872, and at that time, the portion from Beck to Frankfort was called Sixth Street. Jaeger only extended from Reinhard to Nursury Lane. In 1916, the entire street was called Jaeger.

This street is named for Christian Frederick Jaeger, who owned and subdivided large plots of land in German Village. Jaeger was born in 1795 and arrived in Columbus around 1834. Several months after his arrival, Jaeger purchased 140 acres of land on South High Street.

CITY PARK AVENUE: In 1846, Christian Jaeger platted a new addition to Columbus's South End, appropriately called New Street. In 1889, New Street became City Park Avenue, named after the city park itself. (And that's why the façade of Stewart Avenue School says "New Street Schoolhouse, 1874.")

DIXON ALLEY: Providing the western edge for Frank Fetch Park, Dixon Alley extends between Livingston and Beck. Like Briggs, this alley's name has not changed since it first appeared on an 1891 map. (The alley appeared on a map as early as 1856 but was not labeled.)

Dixon Alley may have been named for Joseph Dixon, an early settler in Columbus. In 1797, Louis Sullivant laid out the town of Franklinton, and Dixon was among the first settlers. He also was an original member of the First Presbyterian Church and a church trustee in 1807.

LIVINGSTON STREET: The Livingstons were a prominent family in early Columbus history. Colonel James Livingston was an owner of one of the largest refugee claims taken in Franklin County, and from 1784 to 1791, he served in the New York State legislature. He deeded the land in the refugee tract to his son, Edward Chinn Livingston, who settled in Franklin County in 1804. From 1824 to 1829, Edward Livingston served as an associate judge of the Franklin County Common Pleas Court. These Livingstons were also distant relatives of Alexander Livingston, who founded the Livingston Seed Company and developed the edible tomato, making the city of Reynoldsburg famous.

CONCORD PLACE: This street is indeed mysterious. I'm really not sure why it's called Concord, and I'm even less sure why this is our neighborhood's only "Place." This street may have been named for a ship called *Concord*, which arrived in Pennsylvania on October 6, 1683. The *Concord* carried thirteen families who founded Germantown, Pennsylvania, which is considered the first German settlement in America.

To me, it makes sense that Germans in Columbus may have honored those earlier immigrants, and I suppose remembering their passage was a unique way of honoring them. In 1948, for reasons unknown, Concord Alley became Concord Place. My gut tells me that South Enders of the 1940s and today's villagers had more in common than we realize and that some heavy lobbying took place to make the street sound more prominent.

GRANT AVENUE: Historic maps show sections of the jagged avenue we know as Grant as having been called Stelzer Street, Seventh Street, Born Street and Stelzer Alley. These sections did not become a continuous street until 1931.

There are two Grants for whom our avenue could be named: President Ulysses S. and Colonel A.G. Grant.

Ulysses S. Grant was born in Ohio and was a famous Civil War leader and United States president. Yet according to a description of the 1872 election race between Grant and Horace Greeley, Columbus voted for Greeley by a margin of nearly one thousand votes. Apparently, the Germans believed that Grant was a "friend and protector of a corrupt army of officials," whereas Greeley "had all his life been a friend of the worker."

Since it doesn't sound like Grant Avenue was named for Ulysses S. Grant, the other option may be Colonel A.G. Grant. Although little is known of him, Colonel Grant owned extensive property along the Old Harrisburg Pike.

KOSSUTH STREET: Hooray for consistency! This street has only ever been called Kossuth. It first appeared on an 1856 map of southern Columbus and extended from High Street past Lathrop. At the time, nothing on Kossuth past Mohawk was divided into individual lots. By 1872, Kossuth stretched to Purdy Alley, and by 1886, it extended past Grant.

This street was named for Louis Kossuth, who, in 1852, visited Columbus and was greeted by hundreds of residents. At that time, Kossuth was a former regent and fugitive of Hungary.

Kossuth, who learned to speak English from reading the Bible and Shakespeare, was said to have been "wonderfully archaic and dramatic," and in the United States he was memorialized in statues in Cleveland, in a town in Mississippi and in a county in Iowa.

MOHAWK STREET: This street has been called both Fifth Street (from Livingston to Beck) and Fourth Street (from Sycamore to Reinhard). In 1886, the entire street from Livingston to Reinhard was named Mohawk Street, although no one is absolutely sure why.

The most popular and likely theory is that Mohawk was named for the Native Americans bearing that name, but I have heard two conflicting arguments. Many Mohawks fled to Canada with Loyalists during the Revolutionary War, and some argue that Mohawk Street was named in recognition of their support to Loyalists. To be honest, I'm not sure why, in 1886, the City of Columbus would have recognized that loyalty, so I don't buy that argument.

I've also heard that Mohawk Street was given its name because the Mohawk Indians were kind to early German settlers. I don't have any hard evidence to prove it, but this rationale makes more sense to me, so I buy it for now.

And remember when I mentioned the refugee tract earlier? Here's the scoop.

In 1796, the brand-new United States Congress appropriated refugee lands to individuals from Canada and Nova Scotia who fought on the side of American independence and could not return home because of it. The government was cash-poor but land-rich, so Congress offered land in the untapped Ohio wilderness.

In 1802, John McGowan, who was born in Scotland and immigrated to Nova Scotia, purchased 328 acres of land from the land office in Chillicothe. The refugee tract border was very close to today's Beck Street, and much of present-day German Village is in what was known as McGowan's Addition.

And that's why so many abstracts of title from this neighborhood list the very first transaction as being from President Thomas Jefferson to John McGowan. The witness who countersigned that patent was none other than Secretary of State James Madison.

IN CONCLUSION

Since 2006, my weekly columns for *ThisWeek* Community Newspapers have been a pleasure to write. I learned something new each week, as I hope my readers did, and I had the opportunity to communicate with the residents of German Village in a unique and lighthearted way. As I reflected on which columns to include in this compilation, I saw improvement over time and, of course, a few mistakes here and there. But more importantly, I remembered the purpose I felt in writing each column, the individual who may have suggested the topic and the new attempts each year to focus on the history of the Society's annual events and traditions. This book came along at just the right time—during the Society's fiftieth-anniversary yearlong celebration. There are not many civic associations that can tout the accomplishments the Society can, and I have been proud to share in those accomplishments in the last few years. I hope that the history and memories shared in these columns will help those accomplishments live on for future German Village residents.

ABOUT THE AUTHOR

J ody Graichen is the part-time director of historic preservation programs for the German Village Society. She has held this position since 2005 but shifted into a part-time role with the society in July 2009, when she moved to Athens, Georgia.

Visit us at

www.historypress.net